# HIDDEN
# HISTORY

*of*

# LINCOLN
# PARK

# HIDDEN
# HISTORY
*of*
# LINCOLN
# PARK

*Patrick Butler*

FOREWORD BY MICHELLE SMITH,
ALDERMAN, 43RD WARD

THE
History
PRESS

Published by The History Press
Charleston, SC 29403
www.historypress.net

*Front cover*: Vogelsang's Pharmacy near Lincoln and Fullerton around 1895, back in the days when any self-respecting drugstore had a soda fountain. *Ravenswood/Lake View Historical Association Collection.*
*Back cover, top*: Drama club members at the Seminary Avenue Federated Church get ready for a 1902 production of *Old Maids Made to Order*. *Ravenswood/Lake View Historical Association Collection*; *bottom*: The *Standing Lincoln* statue behind the Chicago History Museum has been replicated in London and Mexico City since it was dedicated in 1887 before an estimated ten thousand spectators. *Photo by Patrick Butler.*

First published 2015

Manufactured in the United States

ISBN 978.1.62619.844.9

Library of Congress Control Number: 2015941628

*To Kathy Hills, who, as always, helped smooth down the rough edges of this book. And the rough edges of its author.*

# CONTENTS

# CONTENTS

# CONTENTS

# ACKNOWLEDGEMENTS

Many thanks to:
Julie Lynch, archivist at the Sulzer Regional Library, once again for her untiring assistance. And Ben Gibson, commissioning editor for The History Press, for clearing away some of the rough spots in the road.

Former Sulzer Regional Library director Leah Steele and former alderman, political analyst and historian Dick Simpson for their encouragement and guidance.

Pat Pastin, my longtime friend and mentor.

The Ravenswood/Lake View Historical Association.

The Chicago History Museum Library.

And a sweet note of gratitude to Melodie Magnuson, who probably made me the only writer in Chicago with a song about his books.

# FOREWORD

I love the 43rd Ward, immortalized in song and story. The shifting boundaries of that ward encompassed various parts of Lincoln Park and the Near North Side over the history of Chicago.

My favorite place of contrast is the Bauler Playlot at Mohawk, Wisconsin and Cleveland. Here's a park with swings and slides immortalizing the notorious alderman Matthias "Paddy" Bauler, who famously declared that "Chicago ain't ready for reform" more than a half century ago. Yet this same community became the hotbed of reform in Chicago beginning in the 1960s and '70s when some aldermen were fighting to expose the excesses and corruption of the Richard J. Daley political machine. I hope to continue following in those footsteps.

Lincoln Park was the first area in the city to be gentrified when young artists, lawyers, entrepreneurs and others bought old rooming houses, saved them from the wrecking ball and restored them. Today, the neighborhood's tree-lined streets and beautiful Victorian brick homes—a few of which survived the Great Chicago Fire—are a testament to the value of the work of those urban pioneers. As the future unfolds, these one-time mean streets have become filled with young families who chose to stay in an urban environment rather than flee to the suburbs. The results of their efforts include excellent public schools, great parks and lovely cultural institutions.

This is our home.

But enough of the serious stuff. I want to see what Pat reveals about our "Hidden History."

# FOREWORD

Is it true that the No. 22 bus, which runs through Lincoln Park, is named after Engine Company No. 22 (today located at Larrabee and Armitage), supposedly because an Engine Company 22 was the first to respond to the 1871 Chicago fire? I don't know, but maybe Mr. Butler will let us know somewhere in this book.

Doesn't Win Stracke, in his famous song "The 43rd Ward," sing about Prohibition not reaching the corner of Willow and Howe? Maybe Pat will enlighten us—or maybe there are just some mysteries of our neighborhood that will forever remain mysterious.

MICHELLE SMITH
Alderman
43rd Ward

# Lincoln Park Has Been Home to Saints, Sinners, Geniuses, Agitators—and Everything in Between

Until recently, members of the John Dillinger Died for You Society gathered shortly before 10:00 p.m. every July 22 in a bar across the street from the Biograph Theater on the 2400 block of North Lincoln Avenue to commemorate the exact moment when America's then most notorious stickup man was "gunned down by G-Men," as the late Chicago "ghost hunter" Richard Crowe liked to put it.

To the tune of a bagpipe dirge, the throng of mourners, which had grown to several hundred since the onset of the Great Recession, made their way to the glittering marquee, where Crowe explained how the widely admired bank robber spent "his last hours on earth" watching *Manhattan Melodrama* with sometime girlfriend Anna Sage, who agreed to keep the FBI informed of Dillinger's whereabouts that evening in return for her not being deported to Romania.

"Tonight we'll follow the very steps John Dillinger took from the theater to the alley where he died that night so long ago," Crowe intoned as the faithful filed around the telephone pole where the mortally wounded Dillinger fell for the last time. There, the assemblage sang "Amazing Grace" as Crowe and theater impresario Mike Flores poured a tributary bottle of whiskey on the pole; half a dozen women in scarlet dresses competed in the annual Lady in Red contest.

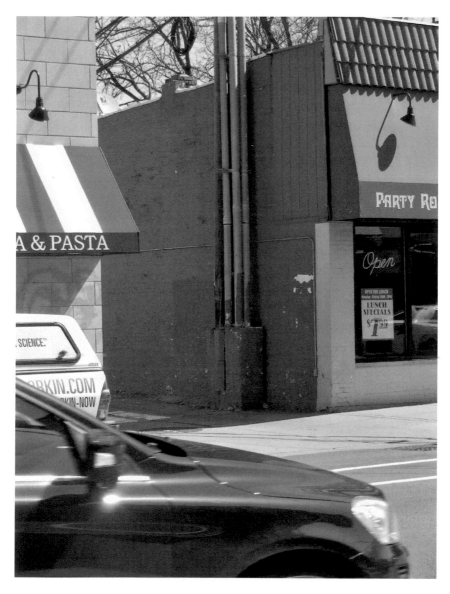

These telephone poles were where John Dillinger died after being gunned down by FBI agents after leaving the Biograph Theater just a few steps away on July 22, 1934. *Photo by Patrick Butler.*

Then the congregants returned to their beers to ponder the similarities between bank misbehavior during the 1930s Depression and today and recall how Dillinger had more than once referred to himself as a modern-day Robin Hood.

Veneration of a far more serious sort has been going on since 1917 at the former Columbus Hospital a few blocks away from where the medical center's founder and the first American citizen to be canonized died in her room, reconstructed by agreement with the developer of the luxury high-rise going up on the Columbus site at 2520 North Lakeview.

The developers, architects and St. Frances Cabrini's Missionary Sisters of the Sacred Heart also broke ground for a national shrine honoring the Italian-born nun who founded sixty-seven schools, orphanages and hospitals throughout the United States, Europe and South America to serve the poor, especially poor immigrants. At the entrance of her shrine there is a piece of her leg bone on display for veneration by the faithful.

While Mother Frances Xavier Cabrini has been dubbed the "Citizen Saint" for being the first naturalized American ever accorded the Catholic Church's highest honor, she might also be called the patron saint of rehabbers for the way she kept everyone honest during the 1905 conversion of a former hotel on the 2500 block of North Lake View Avenue into Columbus Hospital.

Early on the very morning she was to sign the closing papers on the property, she had two of her nuns survey the site just to make sure they were getting what they were paying for. By noon, she had all the proof she needed that someone was trying to cheat her out of a twenty-five-foot strip of land at one end of the block, a deception that would have substantially reduced the value of the site and made future expansion infinitely more difficult and expensive.

No sooner had she straightened everything out and left for Seattle to start an orphanage than it was discovered the contractors were trying to run up huge bills for all kinds of unnecessary work. Mother Cabrini returned to Chicago just as some creditors were about to foreclose on the property. She immediately fired all the scheming contractors and refused to pay for the phony renovation.

The budding saint vowed that from that moment on, she would personally supervise all the work. Within eight months, Columbus Hospital opened with one hundred beds in a dedication ceremony attended by more than four thousand Chicagoans.

The determined Mother Cabrini founded her own order, the Missionary Sisters of the Sacred Heart, after being rejected by two other religious orders that thought she was too frail. She made thirty ocean crossings before dying of malaria at sixty-seven. She was between trains when she stopped in at Columbus Hospital, intending only to make a

quick inspection before moving on to yet another project. She never made that connecting train.

Lincoln Park may produce yet another saint who also dedicated her life to working with the poor—social activist Dorothy Day, a founder of the Catholic Worker movement whose elevation to sainthood by the Catholic Church has even been promoted by some members of All Saints Episcopal Church, where Day worshipped for years before converting to Catholicism at thirty.

On March 12, 2000, exactly eighty-nine years from the day she was baptized at All Saints, more than one hundred Catholics and Episcopalians, led by Cardinal Francis George and Anglican bishop William Persell, met to kick off the canonization campaign and celebrate what one Episcopal priest called her "feisty discipleship."

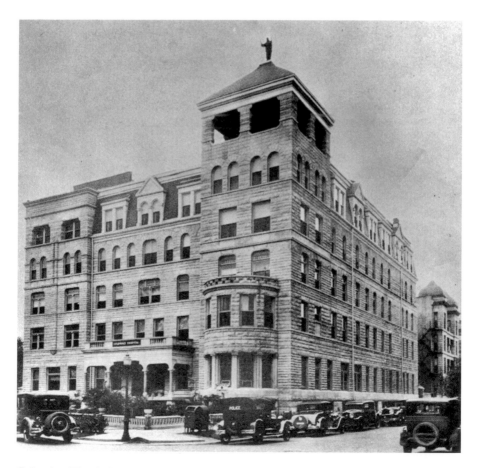

Columbus Hospital in the 1920s. The site has since been converted to condos but still includes a shrine to St. Frances Xavier Cabrini. *Courtesy of the Chicago Public Library.*

That was putting it mildly. Day, who died in 1980, was an often-controversial figure vilified for her support of organized labor, her harsh criticism of the capitalist system and an unbridled opposition to both the nuclear arms race and the Vietnam War. Her middle-class family tolerated her flirtations with socialism as a youthful aberration but thought she was getting too close to the proletariat by taking up with anarchists and founding the Catholic Worker movement and its more than sixty "houses of hospitality" for the homeless in more than sixty cities.

Despite her status as a revolutionary back in the Cold War era, when anyone who advocated sharing the wealth was suspect, Dorothy Day "wouldn't be that unusual a saint," Cardinal George told the ecumenical prayer service. "Read the lives of the saints and you'll find they all challenged the attitudes of their day," said George, adding that while it's much too early to tell whether Day merits the Church's highest honor, "it wouldn't be that much of a surprise."

Dorothy Day, on the other hand, made her own wishes clear after a talk at DePaul University during one of her last Chicago visits. "Don't call me a saint," she said. "I don't want to be dismissed that easily."

# How Local Altar Boy Johnny Weissmuller Scaled Olympian Heights to Become Lord of the Jungle

An entirely different sort of local hero was Johnny (Tarzan) Weissmuller, who grew up at 1921 North Cleveland, was an altar boy at St. Michael's Church and turned to swimming as therapy after being stricken by polio when he was nine.

By his mid-teens, Weissmuller had not only regained full use of his legs but was also taken under the wing of Illinois Athletic Club swimming coach Bill Bachrach.

During the summer of 1921, he won the national 50- and 220-yard championships and set world records in the 100- and 400-meter freestyle events in the 1924 Olympics in Paris.

Four years later, during the Olympics in Amsterdam, after winning the 100-meter race, he retired from competition. A year later, he was "discovered" by the movies while working out at the Hollywood Athletic Club. In 1935, Weissmuller was hired for the title role in *Tarzan the Ape Man* after a single audition.

"They gave me a G-string and said, 'Can you climb that tree? Can you pick up that girl?' I could do all that," he said.

Although he wasn't the first Tarzan, Weissmuller became the most popular, especially since he and his brother, Pete, both lifeguards at the

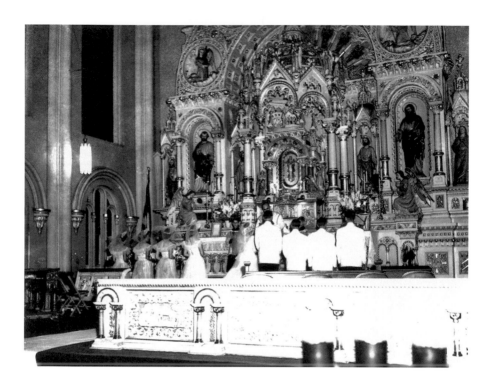

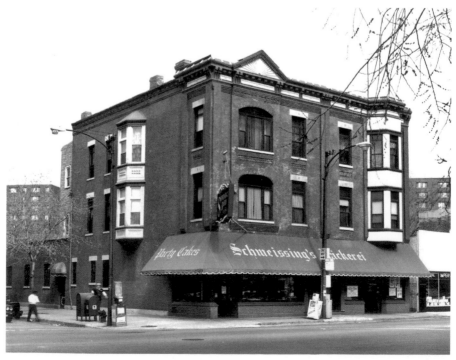

Oak Street Beach, played real-life heroes at least once, rescuing survivors and recovering bodies from the July 28, 1927 sinking of the excursion boat *Favorite* after a squall off the North Avenue Beach.

After deciding in 1948 that "I've been wearing animal skin scanties for too long," a fully clothed Weissmuller became "Jungle Jim," moved to TV and left films in 1968 to promote a series of health food stores, cocktail lounges and the General Pool Corporation in suburban Addison, Illinois.

Voted the greatest swimmer of the first half of the century by the Associated Press in 1950, Weissmuller was finally inducted into the U.S. Olympic Hall of Fame in October 1950—three months before his death at age seventy-nine in Acapulco, Mexico.

*Opposite, top*: Legend has it you knew you were in Old Town if you could hear the bells of St. Michael's Church. Shown here is a wedding around 1948. *Courtesy of the Chicago Public Library*.

*Opposite, bottom*: Schmeissing's Bakery, 1988, was a local treasure for more than seventy years. *Courtesy of the Chicago Public Library*.

# When Al Capone Was "Scared Enough to Send the Very Best" (with Apologies to Hallmark Cards)

Lincoln Park, it seems, has always been home to all kinds of extremes. Where else would you have had the world's first Ferris wheel moved to what was once a prison camp for captured Confederates? Or the grave of what has to be one of the grandest con artists in Chicago's history buried with honors befitting a national hero? Or a gargantuan chain once used to keep British ships from getting close enough to attack West Point? Or grisly crimes that made the depredations of Public Enemy Number One John Dillinger seem like the tantrums of the kid next door having a bad day?

The best known, of course, was the February 14, 1929 St. Valentine's Day Massacre that some historians believe was ordered by Al Capone to keep the Irish mob led by George "Bugs" Moran from taking over the Chicago rackets. Reportedly believing Moran was planning to eliminate Capone and take over his North Side gambling, vice and liquor operations, Capone ordered a preemptive strike while he himself was vacationing in Miami.

To make it look like a routine raid on a well-known Moran haunt, the SMC Cartage Company at 2122 North Clark, two of the Capone gunmen wore police uniforms, while three others wore plain clothes with tommy guns tucked under long trench coats. Everybody arrived in a touring car identical to those used by the Chicago police at the time.

Inside, the five Moran gang members and two "wannabes" were hanging out, waiting for Boss Moran. Moran, credited with perfecting the drive-by shooting, often taunted Capone in press interviews, calling him a "lowlife" and even believing himself to be a better Catholic than Capone because, unlike Capone, Moran didn't run whorehouses.

Capone had had it! Moran had to go.

Ironically, Moran was on his way to join his men when he saw the bogus "police car" pull up in front of the SMC warehouse. Moran turned around and went back home.

A neighbor who heard "a lot of noise" coming from inside the building called police, who found a very agitated German Shepherd dog and one of the gang members, Frank Gusenberg, climbing out from under a pile of bodies.

Gusenberg lived for about an hour and a half at nearby Alexian Brothers Hospital, insisting to the very end that "nobody shot me" despite having fourteen bullet wounds.

According to Chicago crime historian Richard Lindberg in his *Return to the Scene of the Crime*, all six of the dead men were taken to what was then the Drake-Braithwaite Funeral Home, where bigamist Frank Gusenberg's funeral was attended by his two wives.

But nearly half a century later, Canadian promoter George Patey began suspecting he was the massacre's eighth casualty after he bought the bullet-riddled "massacre wall" when the building was razed to make way for senior citizen apartments. When the seven barrels of carefully numbered bricks arrived at the Vancouver, British Columbia airport, customs officials hit him with a 37 percent "building materials" tax.

Patey had planned to rebuild the wall as part of a traveling Chicago gangsters display but nearly got murdered himself by a mob of irate housewives who didn't want his so-called anti-crime exhibit in their suburban shopping center. He next tried to get it featured in the Pacific National Exposition but was again sent packing because authorities considered his display "too violent." In 1969, Patey put the reconstructed wall in a permanent crime museum, which shut down almost immediately for lack of interest.

Still not ready to give up, Patey showcased the wall in the "shooting gallery" of the men's washroom of a Vancouver nightclub, the Banjo Palace. The plumbing even included a target rigged to set off streams of water from appropriate locations on some nearby Grecian statues whenever anyone lined up at the urinal scored a direct hit. At least once a night, however, the

boys on the "range" had to hold their fire long enough for the club's female patrons to file through the latrine and see the wall for themselves.

But interest in the macabre memento again dried up, so to speak. The Banjo Club folded in 1973, and the bricks were put in storage. For George Patey—like Frank Gusenberg and his buddies—crime didn't pay.

Patey, incidentally, wasn't the first to try capitalizing on Lincoln Park's notoriety. Members of the world-famous bank robber's family—including the clan's patriarch, John Dillinger Sr.—were signed to appear in person at the Biograph for a question-and-answer session with the admission-paying public.

While there's no question about Dillinger's current whereabouts, the same can't be said about his brain. Nobody knows exactly how, but shortly after the autopsy, somebody left the morgue with a jar containing Dillinger's thinking cap, which hasn't been seen since.

One of the interns who helped with the dissection, Dr. David Fisher, recalled years later how the brain had been sent up to the second floor after the postmortem so neurologists could see how one of the bullets that killed Dillinger entered through the back and traveled up the spinal cord and into the brain. But that jar evidently never made it up to the lab. It's anyone's guess what happened.

Ironically, the week before Dillinger was tracked to Lincoln Park, where he was staying with girlfriend Polly Hamilton at 2420 North Halsted, the local Lerner Newspapers ran a story on the manhunt, wondering, "Is Dillinger Here?" The day after Public Enemy Number One was bagged after leaving the late showing of *Manhattan Melodrama*, the *Chicago Tribune*'s front page screamed "Kill Dillinger Here."

But it wasn't just his brain that got snapped up by souvenir hunters. Scores of curbside entrepreneurs dipped handkerchiefs into puddles of the folk hero's blood and hawked their grisly mementos up and down Lincoln Avenue. A nearby car with Indiana license plates was stripped down by looters who mistakenly thought the flivver was Dillinger's. Later that evening, thousands of curiosity seekers filed past Dillinger's body, kept on public display at the morgue throughout the night.

# THE OLD NEIGHBORHOOD ALWAYS HAD STUFF THAT GOES BUMP IN THE NIGHT—MAYBE IT STILL DOES!

The alley where Dillinger gave up the ghost and the site of the St. Valentine's Day Massacre aren't the only reputedly haunted places in Lincoln Park.

Right across the street from the Biograph Theater is the resurrected Red Lion Pub, which for years was haunted by a specter that appeared like clockwork between 3:00 and 4:00 p.m. every Sunday. In *Chicagoland Ghosts*, Dylan Clearfield swears he ate at the Red Lion every Sunday for years and always thought it was the help that was causing the upstairs ruckus. When his curiosity finally got the best of him, the owner told him nobody was up there but the resident ghost. Clearfield suspected the wayward spirit was in some way connected with the Dillinger shooting in the alley across the street, but neither he nor anyone else knows for sure.

But that's not where this story ends. That spirit apparently isn't alone.

According to Troy Taylor in his *Weird and Haunted Chicago* guidebook, another ghost emits a perfumed scent and may be the spirit of a young girl who died in the building decades ago. Other ghosts that have been known to frequent the upstairs women's restroom include a man dressed as a cowboy, a blond man, a bearded spirit wearing a black hat and a spirit that has been seen walking upstairs through the downstairs bar.

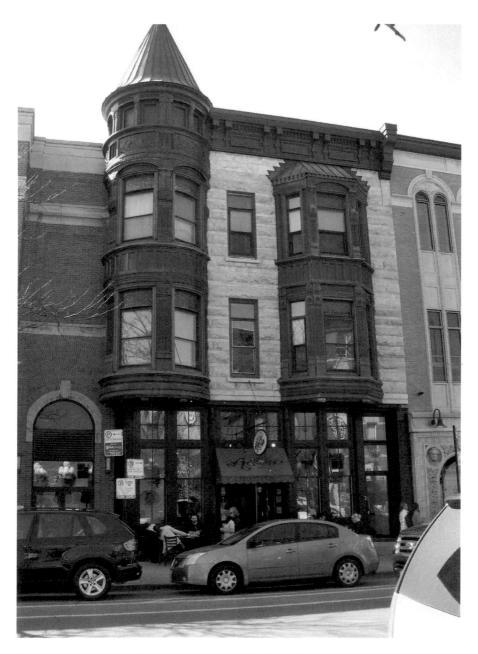

The site of the former That Steak Joynt at 1610 North Wells doesn't appear to be haunted. But back in the day, "the Joynt was jumpin'," as one eyewitness said. *Photo by Patrick Butler.*

But wait. It gets even better!

When architect John Cordwell bought the pub and began renovations, he installed a vintage stained-glass window over a stairway with a plaque memorializing his father, who had been buried in England without a tombstone. Customers said they felt a strange presence as they passed that window. Some even reported experiencing dizziness. Cordwell wasn't surprised. He himself felt an unexplained strong presence around that window. According to Taylor's *Weird and Haunted Chicago*, Cordwell suspected it could have been his father's spirit.

About a mile south, in what used to be the Old Town nightlife strip, there have been reports of strange happenings since the 1980s and even earlier at That Steak Joynt, 1610 North Wells Street, and the adjoining Piper's Alley. These reports included some invisible force knocking over a barmaid who was cleaning up after closing time, shadowy figures and the sounds of singing seemingly coming from nowhere. These and other seemingly supernatural happenings over a number of years prompted several séances attended by notables including Pat Brickhouse, widow of the legendary Cubs broadcaster, according to Janice Tremeear's *Illinois Haunted Route 66*. During one of those encounters, a well-known local medium, Robert Dubiel, contacted three different spirits: the architect who designed the 1880s landmark, a female customer of the long-gone Piper's Bakery and a spirit who declined to introduce himself.

Workers in the cleanup crews reportedly quit, complaining of an unexplainable eerie feeling as they walked through certain areas in the posh Victorian-style restaurant. A few complained of being groped by unseen hands. One barmaid was grabbed by what she described as an invisible force that dragged her to a stairwell while she was cleaning up after closing time. According to Tremeear's account, the woman was sprawled on the floor when she was found by the manager. Another time, a bartender working on the books reported seeing a pair of luminescent yellow eyes.

On April 6, 1991, *Chicago Sun-Times* reporter Celeste Busk joined a paranormal team that spent the night at That Steak Joynt. According to the team's report, "Many disturbances occurred, including lights not made by anything in this world. Cold spots, strange magnetic readings picked up in the dining room, and psychic impressions from the two team members near the *Happy Peasant* bust in the bar." Pictures taken with a 35mm camera supposedly backed up the report. The photos taken of the *Happy Peasant* showed "strange figures of bluish and white lights" hanging around the peasant bust.

During a second investigation, the Ghost Research Team brought along Janet Davies from Channel 7, ABC Eyewitness News. By all accounts, "the Joynt was jumpin'" that night.

Billy Siegel, one of the owners of That Steak Joynt, always wondered if the hauntings had anything to do with the two still-unsolved murders in Piper's Alley said to have occurred sometime around the turn of the nineteenth century. Siegel's theory was that the female bakery customer and the unidentified man contacted during Dubiel's séances could have been the murder victims.

But there's apparently more.

On the second floor were paintings of early Chicago merchants William and Katherine Devane that had been bought by That Steak Joynt's interior decorator, Warren Black, from the owner of Victorian House Antiques, then at 806 West Belmont Avenue, who complained of having bad luck ever since he first bought the portraits. Once, he said, Mrs. Devane's picture fell off the wall, breaking his toe.

The dealer was apparently so unsettled by the paintings he said he planned to destroy them if he couldn't sell them soon.

Once the portraits were in their new home at That Steak Joynt, customers started feeling a cold spot or an unaccountable rush of wind whenever they passed those paintings.

Soon after the death of Siegel's partner, Raudell Perez, That Steak Joynt closed. It reopened after remodeling as the Adobo Grill; nobody has reported any unusual occurrences in the new incarnation.

So far.

On the other hand, nobody has quite figured out what was really going on at St. Michael's Church, 1633 North Cleveland Avenue, the day the life of the spirit, so to speak, was really shaken up. In her book *Chicago Haunts*, Ursula Bielski recounts a story she said was making the rounds about how the late Father "Curly" Miller, who had done a number of exorcisms at the parish years earlier, reportedly saw an elderly woman with cloven hooves walk into the church. In a more recent incident, several parishioners swore they saw a "hooded, hoofed" figure waiting in the communion line. While it could simply have been an oddly dressed or disfigured congregant, Bielski said another theory was that it might have been some "demon" come back to haunt the once-resident exorcist.

Whatever Father Miller and others might have seen—or thought they saw—remains a mystery. But in a 1973 *Tribune* story about strange apparitions in local hauntings, Old Town resident Arlene Zoch told

reporter Walter Oleksy that hauntings in her neighborhood weren't all that uncommon, adding that homes she'd lived in on Sedgwick and Belden Avenues had been haunted.

In fact, one of those houses was "full of spooks. Sometimes the piano or phonograph would start playing all by themselves. You could pull the cord out of the wall, but the phonograph would still play. It even played records we didn't own," Zoch said.

"My daughter saw an old-fashioned ghost girl more than once. And they played together. But when the ghost man's ghost dog came into the house, our three live cats went wild. I even sprayed the house to get rid of any dog odor, but the heavy scent of a wild hunting dog filled the house again."

Zoch added, "The scariest ghost or whatever it was that I'd heard of was the one that walked into St. Michael's Church"—the one with devil's hooves.

Father John Nicola, one of the Catholic Church's experts on things that go bump in the night, said, "98 percent of ghostly phenomena are due to fraud, deception and just plain superstition. But that remaining 2 percent may have something to it."

Nevertheless, he added, of all the many cases he's investigated over the years, he's never actually had to call for a formal exorcism, in which demonic influences are suspected and the entity is addressed directly and commanded to depart. It also requires the express permission of the local bishop, he added. Instead, he's used an "informal" rite involving a blessing of the building and calling on the ghost to renounce Satan and all his works.

While no priest is known to have performed that kind of ceremony in recent years here as far as anyone knows, it happened at least once before in Lincoln Park.

During the 1918 influenza epidemic, a priest from St. Vincent's Church was called to an apartment on Kenmore Avenue where two children had succumbed in the same week. Family members recalled decades later how doors and drawers opened and closed, items were moved around and a picture fell off a wall.

Nothing really scary. They were just being kids, one of them said.

"Your little aunt and uncle probably just didn't want to be forgotten," the relative told a reporter.

# After Lots of Skullduggery, Comedian Del Close Got the Last Laugh on the World After All

Longtime Second City headliner Del Close always wanted to keep working as long as he could, even if it was only playing Yorick in Shakespeare's *Hamlet* now and then.

So on his deathbed at Illinois Masonic Hospital in March 1999, Close had one final favor to ask his professional partner and close friend Charna Halpern: to have his head removed and the skull donated to the Goodman Theater, where it would be used in its productions of *Hamlet*. Close's only request was that he be duly credited in the program as portraying Yorick.

The skull was presented to Goodman with much fanfare, and Close did do several posthumous appearances—until seven years later, when a *Chicago Tribune* story raised serious questions about the cranium's provenance.

The *Tribune* showed pictures of the skull to several experts, including Anne Grauer, a paleopathologist in Loyola University Chicago's anthropology department, who said the skull had all the earmarks of a store-bought "teaching skull" that had more teeth than Close did, some old rust marks and other indications that its previous owner had died at least sixty years earlier—not seven.

Halpern fessed up to buying someone else's skull but said she did it with the best of intentions.

After Del Close made that last request, she said, "I really did try to have it done. But the hospital wouldn't do it. So I called the Illinois Pathologists Association and a few other places. They were having all kinds of meetings, but nothing was happening. Before I knew it, the hospital morgue was calling me to get the body out of there," Halpern said during an interview on WBEZ shortly after the *Tribune* broke the story.

"I had to cremate the body, then I went to a place that used to sell skulls. I was able to shop for one that had that same jaw line and crooked smile. It looked like Del. For me, that skull was Del. I had to make it happen any way I could. He was my professional partner for 17 years. He was my mentor. It was out of love and honor and not because I was trying to hoax anyone. I just want everyone to understand that. I couldn't understand why anyone would want to take this away from him."

He's still a strong influence at IO (formerly the Improv Olympics), Halpern said. "His ashes are in an urn on an altar at IO."

All things considered, like Yorick himself, this modern-day jester wouldn't have minded a little innocent deception, Halpern said. After all, she explained, "he was a musician, illusionist, actor. He wanted to keep working. He wanted to continue to entertain. What's so terrible about that?"

Close was one of the early stars of the comedy troupe at the improv theater at 1608–16 North Wells Street as an actor, magician and illusionist. He once worked as a circus fire-eater, directed Second City's comedy troupe for twelve years, performed earlier with the Compass Players Mike Nichols and Elaine May and worked as *Saturday Night Live*'s acting coach.

Despite all the hoopla, Del Close apparently wasn't the first actor to do the "ah, Yorick" scene after death. When the notoriously alcoholic George Frederick Cooke died in New York in 1812, the then-prominent actor's head was passed on to a pathologist who wanted to study his brain. The skull was later passed on to a doctor who gave it to a medical school, where it ended up in a library display case. But before he died, the good doctor admitted he had once loaned the skull for a *Hamlet* production.

Close, however, had been planning an ultimate encore performance at least five years before he died. "He kept saying, 'Don't forget the skull. Don't forget the skull,'" Halpern told the *Tribune* reporter.

# Joe E. Lewis Wasn't Playing for Laughs the Night He Stood Up to the Mob—and Lived to Talk About It

Another of Lincoln Park's more memorable crimes forced a promising singer to turn into a world-class comedian. But there was nothing funny about it to Joe E. Lewis, headliner at the Green Mill, still in business at Lawrence and Broadway, where the one-time Joe Klewan from New York's Lower East Side was pulling down $650 a week. Good money, but peanuts compared to the $1,000 a week plus a share of the gambling profits the owners of the New Rendezvous Café, near Clark and Diversey, were offering Lewis to jump ship.

When Lewis gave his notice, "Machine Gun" Jack McGurn had a fit, warning Lewis he'd never live long enough to open at the new club. One of the suspected triggermen at the St. Valentine's Day Massacre, McGurn was never charged, largely because of his "blonde alibi," girlfriend Louise Rolfe, who swore they had spent that entire Valentine's Day together. In addition to doing odd jobs for Capone, McGurn—whose real name was Vincenzo Gibaldi—was a partner in the Green Mill who decided that if he couldn't have Lewis working his club, nobody could.

McGurn proved as good as his word. Early on November 9, 1929, three men knocked on the door of Lewis's room 332 at the Commonwealth Hotel, 2757 North Pine Grove, beat Lewis senseless and slit his throat from ear to

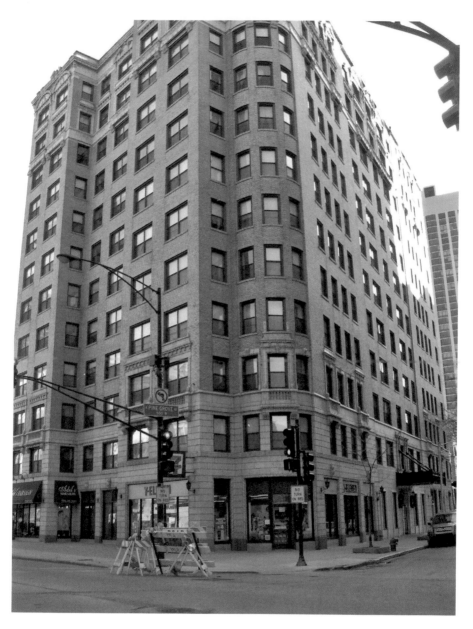

Now a quiet residence mostly for seniors, the Commonwealth Apartments at 2757 North Pine Grove was the scene of an especially brutal gang hit, even by Chicago standards. *Photo by Patrick Butler.*

ear, cutting his vocal cords. Despite his injuries, Lewis managed to crawl down the hallway to the elevator, where someone called police, who got him to Columbus Hospital. He began a slow convalescence that included learning how to talk again.

The determined Lewis was back on stage at the New Rendezvous two and a half months later. According to respected Chicago crime historian Richard Lindberg, Sophie Tucker, the legendary "Last of the Red Hot Mamas," even passed up a $5,000 gig to be there for Joe E. Lewis's first night back at the New Rendezvous Café.

No longer a singer, Lewis fought his way back, this time to comedic fame that included USO performances with Ray Bolger during World War II; a number of movies from 1931 to 1968, when he played himself in *Lady in Cement*; frequent appearances on the *Ed Sullivan Show*; appearing as a "Mystery Guest" three times on *What's My Line?*; and seeing his autobiography, *The Joker Is Wild*, made into a 1957 movie starring Frank Sinatra, Mitzi Gaynor and Jeanne Crain.

"Machine Gun" McGurn, on the other hand, was gunned down on February 15, 1936, in a bowling alley at Chicago and Milwaukee Avenues. The killers even left a Valentine poem:

> *You've lost your job. You lost your dough,*
> *your jewels and cars and handsome houses.*
> *But things could be worse you know*
> *At least you didn't lose your trousers.*

# BREWSTER APARTMENT BUILDING PROVED ILL-STARRED FROM THE START FOR ALMOST EVERYONE INVOLVED

Was it a curse or just coincidence?

On July 31, 1895, Bjorn Edwards fell eight stories to his death while he was checking out the roof skylight of the Brewster Apartments—then known as the Lincoln Park Palace—at Diversey and Pine Grove. The publisher of the *American Contractor* trade paper was nearing realization of his dream of creating what he hoped would be the world's finest apartment building when he made that single misstep on a piece of loose scaffolding. Edwards was rushed to nearby Alexian Brothers Hospital, where he died about two hours later.

On July 31, 2013—exactly 118 years later to the very day—a century-old water tank fell off the roof of the Brewster building, seriously injuring three people on the parking lot below. The water tank—built directly over the penthouse where silent film star Charlie Chaplin reportedly lived while working at Essenay Studio in Uptown—fell into the parking lot around 10:00 a.m., which was the deadline for some residents of an adjoining building to move out.

Coincidentally, the Brewster was also where "Chucky," the homicidal doll, lived in the 1988 movie *Child's Play*. During filming, crowds jammed Diversey and Pine Grove for the scene where the devilish doll tossed a convincing-

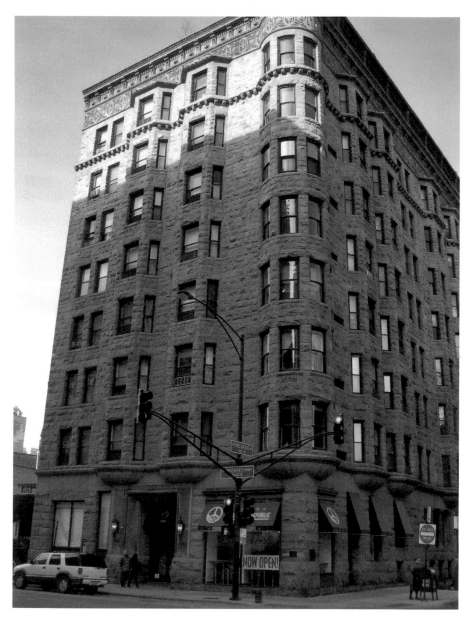

The Brewster Apartments—originally dubbed the Lincoln Park Palace—seem to have had more than their share of bad luck since they went up in 1895. *Photo by Patrick Butler.*

looking mannequin out of a window to certain death on Diversey. On the day of the film's release, protesters massed in front of MGM studios warning that the horror film would incite children to violence. Despite several actual

torture/murders believed linked to the film, five sequels followed. After all, the original *Child's Play* had made a reported $192,042,375 worldwide.

The Brewster would have been noteworthy even without construction mishaps, falling water tanks and evil toys. While there is some dispute whether the "Little Tramp" actually lived at the Brewster, there's no doubt former Illinois governor John Peter Altgeld lived there after being turned out of office following his controversial pardon of three of the so-called Haymarket Bombers who hadn't already been hanged following a rigged trial.

An official Chicago landmark since 1982, the Brewster was state of the art for its time. There were electric lights and telephones in all the rooms. A restaurant, pharmacy, doctor's office and messenger service were on the first floor. There was even a private "ladies' entrance" on Pine Grove and a separate sitting room for men.

But not everyone was ecstatic.

Long before neighborhood organizations became accustomed to having a say on what kinds of buildings went up on which blocks, Edwards's neighbors made no secret of their disdain at having an apartment building in their backyard, no matter how upscale that building might be. The Lincoln Park Palace would become the tallest building for blocks around. According to Raymond Johnson in his book *Chicago History: The Stranger Side*, Edwards's neighbors even whispered how the first-time developer had been "acting queerly" ever since the job started. They insisted it was "obvious evidence" of a "disturbed mind."

Despite Edwards's death, the job was finished by his wife, Mary, a year later at a cost of $300,000. She also bought the adjoining building now occupied by Yak-Zies Bar. While all but one of the Lincoln Park Palace's sixty apartments were rented shortly after they became available, the building never turned a profit for its original investors. Mrs. Edwards lost her Palace to a minor partner with a $20,000 stake in the project, retired General Henry Strong of Lake Geneva, Wisconsin. Mary Edwards; her sister Frieda Dalb; her brother-in-law Frederick Dalb; Dalb's wife, Mathilda; and their daughter Agnes all moved into the Lincoln Park Palace as some of the first renters.

# Before Tony Lincoln Park Got That Way, Indians, Escaped Slaves, Even Kashubians Found a Home

Lincoln Park was settled in 1824 as an army post near today's Clybourn and Armitage intersection to keep an eye on the scattered Indian settlements along Green Bay Trail (now Clark Street).

What is now one of the city's most gentrified communities was home to German revolutionaries fleeing the law after the failed 1848 uprisings. Following the Germans came one of America's largest settlements of Kashubians—Polish in national allegiance while remaining a distinct culture with its own language within the old Prussian kingdom. For decades, St. Josephat's parish was a center of Kashubian life in Chicago, founded in the mid-1880s by "Kashubs" fleeing Bismarck's late nineteenth-century Kulturkampf (Culture War) against Catholics.

In 1863, reaper inventor Cyrus McCormick bankrolled the Presbyterian Theological Seminary, later named McCormick Seminary, which reportedly served as a stop along the Underground Railroad during the last days of slavery and was a gathering place for refugees fleeing the 1871 Chicago fire. Those escaping the fire prayed that what many of them thought was the end of the world would be mercifully swift.

Others fled to the lakefront and into the open graves in the City Cemetery next to the newly created Lincoln Park. Today, the old McCormick campus

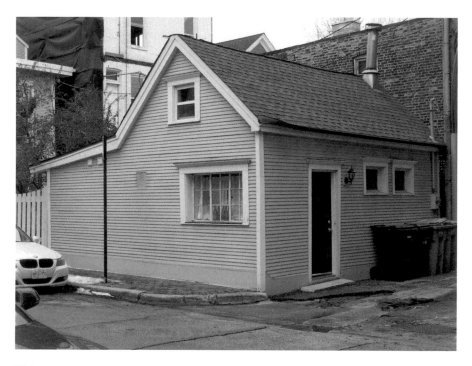

This two-room worker's cottage at 350 West Menonomee is one of the last remaining "relief shanties" built by the Chicago Relief and Aid Society after the Chicago fire. *Photo by Patrick Butler.*

is part of DePaul University. One family reportedly buried its most precious possession, an organ, as the flames crossed North Avenue. For all anyone knows, it may still be buried there today.

The two-day fire devoured between $220 and $300 million worth of property and killed between 200 and 300 people and left 100,000 homeless in a four-square-mile area before finally burning itself out at the home of brewer John Huck at Fullerton and Clark (Or was it Dr. John Foster's place near Clark and Belden? Accounts differ.) with the help of what some reports claimed was Chicago's first rainstorm in weeks. By then, hundreds of urban refugees were already being sheltered at churches and surviving public buildings like the recently built Lincoln School on Kemper Street. Federal troops and state militia units were on patrol under command of Civil War general Philip Sheridan, himself a Chicago resident whose home, if not his army headquarters, was spared by the fire.

While several buildings such as the Lincoln Park superintendent's home and the nearby pest house for incurables survived the blaze only to be

leveled later by the wrecking ball, a handful of Chicago fire buildings remain today. Next to the iconic water tower and pumping station, the best-known remnant of the blaze has to be the frame cottage at 2121 North Hudson, whose owner, Officer Richard Bellinger, his brother-in-law and another policeman ripped out the wooden front steps, sidewalk and picket fence to create a fire break and then covered the roof with water-soaked rugs and blankets and doused the roof with still more water every time a burning ember landed on the building. When his own well ran dry, Bellinger ran to a nearby water storage ditch for refills. The legend that Bellinger finally saved the house by dousing the building with cider is just that—a legend—Mrs. Bellinger reportedly recalled years later.

Another local Chicago fire story—that the Clark Street bus was named #22 in honor of the first fire engine to respond to the 1871 fire—is also a fanciful legend. None of the seven engines that responded to the first alarm sounded around 9:00 p.m. was the #22. It was probably the #5.

The house Bellinger bought for $500 less than a year before the fire was reportedly on sale in late 2011 for more than $1 million. Ironically, it was designed by W.W. Boyington, the same architect who created the water tower.

Herculean as Bellinger's efforts were, the real heroism was going on not far away at the new St. Joseph's Hospital, 2100 North Burling, where doctors and nuns directed by Civil War nurse Sister Walburga Gehring worked around the clock even as the blaze was raging two blocks away from the new building at one point. According to Sister Walburga's diary, the first word the hospital had of the fire was when the nuns were awakened early on October 8 when "a wagon loaded with children and all kinds of furniture drove into our yard. The children told us the city was on fire. We could see the great lights. The sky was red with it."

Sister Walburga and her nuns headed toward the fire "to see if we could do anything. As we advanced, we found the heat so great and the wind so high we were obliged to turn back. All day, people flocked to the little hospital seeking water," she wrote. As the fire began closing in on the hospital, Sister Walburga hired some wagons and began evacuating the patients to open prairie a few miles north.

By midnight, the wind had shifted and the rain fell, but not in time to save the new building. Fortunately, the old building survived unscathed, so the nuns and their patients were able to move back to their old digs.

According to one account of the fire's aftermath, the nuns' four-year, $30,000 loan ran out and Bishop James Duggan said he didn't have any

Another building that survived the Chicago fire is this farmhouse on Armitage and Mohawk Avenues. It was built in 1863 for about $800. *Photo by Patrick Butler.*

money. "It gave us a lesson to rely on God alone," wrote Sister Walburga, who eventually got funding from the Chicago Relief and Aid Society. "We owe our success in Chicago, under God, to the Relief and Aid Society," she added.

Like St. Joseph's Hospital, it's no exaggeration to say that Chicago itself was literally rebuilt from the ashes of the 1871 fire. Especially the old Relic House at Clark and Armitage.

In early 1872, a man named Rotting built a cottage out of assorted debris, including melted sewing machines and dolls' heads, just a few blocks south of the city limits at Fullerton Avenue, where the conflagration finally burned itself out after doing over $200 million worth of damage over twenty-five hours.

Ten years later, Rotting sold the building to Philip Winter, who in 1886 sold it to William Lindeman, who ran what may have been the only bar and restaurant in the entire city with a Chicago fire "nostalgia" theme. Eventually, however, even that apparently wasn't enough. Throughout its lifetime, the local curiosity was moved to three different locations before

ending up at 2037 North Clark, where it finished its days as a shoeshine parlor before it was finally razed in 1929 to make way for stores and an apartment building.

According to legend, the Bellinger Cottage at 2121 North Hudson Street survived the Chicago fire because its owner, Officer Richard Bellinger, doused the house with cider when he ran out of water. *Photo by Patrick Butler.*

Still another relic of the Great Fire is St. Michael's Church, 1633 North Cleveland. Though gutted by the fire, with the steeple totaled and the bells fused together, most of the walls survived but bear faint traces of soot from the inferno that destroyed most of the area. In the aftermath, the *Chicago Tribune* called the devastated church "the most imposing ruins on the North Side."

Within a year and three days, the church had been rebuilt, with some of the ashes sealed in a time capsule opened in 1971. A century later, the ashes were put in packets that sold for $18.71 to help defray expenses.

Founded in 1852, St. Michael's Church was built on land donated by brewer and former alderman Michael Diversey to serve the growing German Catholic population, which had been pressing for a parish of its own as an alternative to what they considered the "cultural domination" by what was then the predominately Irish clergy. When completed in 1869, the two-hundred-foot steeple made St. Michael's the tallest building in Chicago until the Chicago Board of Trade came along in 1885. To this day, people still say that if you can hear St. Michael's bells, you know you're still in Old Town.

In the aftermath of the 1886 Haymarket Bombing, Captain Michael Schaak and some of the major newspapers inferred that anarchists were planning to blow up the church for reasons never quite made clear. Nevertheless, stories like these helped drive a wedge between the German community's more conservative elders (many of whom ironically came here after fighting in Germany's 1848 revolutions) and the younger labor activists.

By the 1920s, St. Michael's boasted Chicago's largest Catholic school, with more than 1,800 children. Over time, both the elementary and high schools closed as enrollment dwindled as the neighborhood changed, first from German to Hispanic and, more recently, to the upscale young professionals who benefited from decades of urban renewal started in the 1960s.

# But Not Everyone Was Pleased When Lincoln Park Started Getting Too "Trendier Than Thou"

As far back as the Depression and continuing during and after World War II, homes and even apartments were subdivided to accommodate low-income renters, transients and a postwar housing crisis. Residents included people like "Outsider Artist" Henry Darger, who lived more than forty years in a one-room apartment on the 800 block of Webster Avenue, not far from Children's Memorial Hospital, where he worked much of his adult life as a janitor.

Since the early twentieth century, in fact, Lincoln Park had been a magnet for assorted eccentrics and geniuses like *Wizard of Oz* creator L. Frank Baum (remembered today through Oz Park at Webster, Burling, Larrabee and Armitage), futuristic designer Buckminster Fuller (of geodesic dome fame) and Columbian Exposition serial killer Dr. H.H. Holmes (alias Herman Mudgett), who lived for a time on Wrightwood near Halsted.

Self-styled bohemians, beatniks, starving artists and perpetual students had been trickling into the area since the Depression, when landlords began converting apartment buildings and once-spacious mansions into rooming houses. Rents plummeted and remained among the most affordable in the city until the pendulum swung the other way and the neighborhood started going upscale in the 1970s, pricing many tenants and even property owners out of the area.

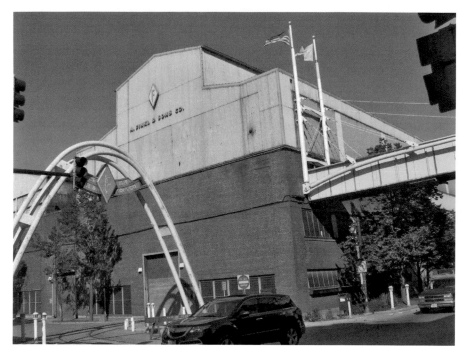

Soon after this picture was taken, the Finkl Steel plant was razed. The North Branch Works' Mike Holzer argued for putting high-tech industries on the twenty-eight-acre site. *Photo by Patrick Butler.*

Ironically, gentrification probably saved DePaul University, originally founded as St. Vincent's College in 1898 to serve the needs of working-class youth. In 1911, DePaul became one of the first Catholic colleges in the United States to admit women, and the following year, it awarded bachelor's degrees to Sisters Mary Leahy and Mary Teresita. George Cardinal Mundelein—who had earlier ordered DePaul not go co-ed—was not amused. He reportedly had the Vincentian religious order, which runs DePaul, demote Father Francis McCabe, the school's president, to running a parish in New Orleans.

DePaul played its role in both world wars. The theater, converted into a temporary army barracks in 1918, had even housed up to 280 students by the time the Armistice was signed. A generation later, DePaul was giving free classes for would-be war workers and integrated crash courses into the curriculum for students wanting to become naval officers.

In the late '60s, just as DePaul was expanding its programs, the neighborhood had deteriorated to the point where university officials

were seriously considering a move to the suburbs but decided against it as the city's "General Neighborhood Renewal Plan" was taking hold. Unlike the urban renewal experience elsewhere, watchdog groups like the Lincoln Park Conservation Association (LPCA) did their best to prevent indiscriminate bulldozing by the Chicago Land Clearance Commission. Opponents like the Concerned Citizens of Lincoln Park and the Young Lords Organization demanded an immediate halt to what city planners were calling "community conservation."

Like Uptown a few miles to the north, Lincoln Park quickly deteriorated during and after World War II as transients—many of them defense workers—moved into hastily converted rooming houses. Groups like the Old Town Triangle Association (OTTA) quickly materialized to turn things around, starting with pest control programs and then working up to demanding stricter enforcement of zoning ordinances and enlisting help from local banks with loans for property improvements and public funding for youth, recreational and anti-crime programs.

The Menomonee Club for Boys and Girls, 244 West Willow, was organized in 1945 as a way to keep at-risk kids busy and off the streets. Three years later, backers of that club organized the Old Town Triangle Association to turn around what they saw as an equally at-risk neighborhood.

After passage of the 1949 U.S. Housing Act, OTTA leaders met with local aldermen to hammer out a slum-clearance program and joined forces with other groups to eventually form the Lincoln Park Conservation Association. By 1954, a good part of Lincoln Park had been included in a "conservation" (aka slum clearance) program that included closing Ogden Avenue, building a major shopping district at North and Larrabee and widening North Avenue. A new park complete with a fully equipped playground would go up on a four-square-block tract next to Waller (now Lincoln Park) High School, and two smaller playgrounds were planned for other parts of the Old Town area. Also planned were six hundred units of low- to middle-income housing.

But support for the program began to sour once it was learned the demolition plans called for removing about 330 individuals, 460 families and 146 businesses. Groups like the Concerned Citizens of Lincoln Park and the Young Lords (a one-time street gang that went political in the mid-1960s) voiced concern that hundreds of blacks and Hispanics were being forced out in the name of "urban removal," as the "conservation" program came to be called. "We shall not be moved" became a battle cry that mysteriously appeared almost overnight on more than one wall during those frequently turbulent years.

Within a few years, Lincoln Park had indeed gone from borderline slum status to one of Chicago's most expensive neighborhoods. A landlord who bought a brick two-flat on the 2200 block of Dayton for about $15,000 in the late 1950s, for example, sold the property in 1978 for more than $300,000. The building was gutted and transformed into a spacious single-family home worth close to $1 million in the early 2000s.

In many cases, it was the location that fetched the stratospheric prices. On parts of Howe Street near Armitage, even pricey Victorian-era buildings were razed to make way for full-blown mansions.

Not that minorities didn't try to get a piece of the action, especially in construction jobs. In 1972, Jose Ovalle, director of a newly formed Latin American Task Force for the Building Trades, said Hispanic businesspeople would love to hire their own people for those jobs but couldn't because they themselves found it almost impossible to get contractors' licenses. Out of the estimated $8.5 billion expected to be spent on construction in Chicago that year, only about $400,000 worth would be done by Latinos, Ovalle said. Only two Hispanics in the entire city held contractors' permits, he added.

"Three thousand years ago, our people were building highly complex pyramids [in Mexico and Central America] just like the Egyptians. But today we can't even get a union card to fix a sink or finish a back porch," he said.

Ovalle noted that he himself had an electrician's license and could easily do contracting anywhere outside Chicago. But in the city itself, where most Hispanics live, the permits were sewed up so tight a Hispanic couldn't even slip money under the table to get one.

"Last year, I even met with Cardinal [John] Cody for about an hour and tried to explain our problems. He's undoubtedly a very fine man. He said he would see what could be done, but I haven't heard from him since," Ovalle said.

Ovalle warned that although the city's Democrats had usually taken Chicago's Hispanics for granted, the "Machine" may have to beg for their support in the next election. Republican Party leaders, he added, had been wooing Ovalle's coalition and other Hispanic groups.

Ovalle's warning would have a familiar ring in the 2010s when some national-level GOP leaders were calling for a concerted effort to win over the Hispanic vote in the same way the Democrats co-opted the black vote in the early 1930s.

But "Cha-Cha" Jimenez and the Young Lords weren't the only ones not so eager to jump on the urban renewal bandwagon. There was Harley Budd, who inadvertently became the poster boy for resistance.

The Second City portals, 1616 North Wells Street, have done their share of traveling. They were removed from the old Garrick Theater when it was demolished in 1960, incorporated into Second City's earlier location at 1842 North Wells Street and then moved to their present home. *Photo by Patrick Butler.*

If you look hard, you may still see a faded "Save the Tap Root Pub" bumper sticker on a wall that probably hasn't been cleaned since the early 1970s. That's how long it's been since the city tore down Budd's bar and restaurant at 1762 North Larrabee, ending a chapter in Chicago history that made Budd a living rallying point against rampant gentrification.

The lifelong Ranch Triangle neighborhood resident bought the seafood restaurant and tavern in 1962. According to Budd's research, the building—known under various names and an apparent survivor of the Chicago fire—had been a neighborhood hangout since Civil War days. And where else would you find a herd of friendly cats that had the run of the place?

So when that neighborhood was declared an urban renewal zone and the city pulled Budd's liquor license, the loyal patrons brought their own hooch and Budd collected a reported 200,000 signatures on petitions begging the city to spare what many argued was a de facto historic landmark. Not

surprisingly, Budd was soon joined by author/radio personality/proletarian activist Studs Terkel himself.

But even that wasn't enough.

In 1972, armed with an eviction order, city officials and police forced their way into the Tap Root and carried Harley Budd out into the street. A short time later, the wrecking ball finally got its way. But even then, Harley Budd wasn't finished. He opened a new Tap Root Pub about a block away at 636 West Willow Street. He died of pneumonia eighteen years later at Grant Hospital, survived by a son and daughter and legions of fans who still remember.

# Elegant Crilly Court Was Home to Budding Society Ladies—and More Than a Few Ladies of the Evening

Like Judge Lambert Tree, Daniel Crilly liked to have artists for tenants in his row houses and apartment buildings on the 1700 block of Crilly Court. Of course, these artists and students generally came from "reliably respectable" backgrounds, just like the middle-class businessmen and the Blue Book newlyweds who typically used the 1700 block of North Crilly Court as a way station between their parents' Dearborn Parkway mansions and Lake Forest, Wilmette or Winnetka.

And like Daniel Burnham, Daniel Crilly made no little plans.

The Pennsylvania-born one-time Iowa City construction worker turned Chicago meat packer already owned an office building bearing his name and a large home, and in 1884, he bought a four-acre parcel that once belonged to Florimond Canda, an officer in Napoleon III's army who inherited the Chicago property from his brother, Charles.

Crilly built his trademark Queen Anne town houses on the west side of the then-private street he named after himself, and eight years later, he started building an apartment complex on the other side of the street. True to form, he named those buildings after each of his four children: Edgar, Eugenie, Erminne and Isabella. By the time he died in 1921, Crilly left real estate holdings worth well over $1 million to his children—the equivalent of $2.5 million per child in today's dollars.

Daniel Crilly never dreamed, of course, that his "perfect" community would someday fall on hard times and become a collection of flophouses, boardinghouses and seedy tenements where, according to Shirley Baugher's "Living in Interesting Times" blog, "landladies sat on the front stoops and tossed bones to dogs passing by."

Or that it would become the cradle of America's first documented gay rights organization and home to possibly two round-the-clock bordellos.

There's a plaque at 1710 North Crilly Court noting that gay activist Henry Gerber founded the Society for Human Rights (SHR) while living there in 1924–25. Born in Bavaria in 1892, Josef Henry Dittmar, as he was originally known, immigrated here in 1913, just before the start of World War I. When the United States got involved, Dittmar/Gerber—as a resident enemy alien—was given a choice of internment or enlistment in the U.S. Army. Opting for the army, Gerber worked on a military newspaper in Allied-occupied Germany, where he was pleasantly surprised to find a very active, open gay community.

Heartened by what he found in Germany, Gerber organized a gay rights group when he got back home. In his application for a state charter, Gerber said SHR's purpose was to "promote and protect the interests of people who by reason of mental and physical abnormalities are abused and hindered in the legal pursuit of happiness…and to combat the public prejudices against them by dissemination of facts according to modern science among individuals of mature age."

At a time when homosexuality was illegal in Chicago, SHR members took pains to meet secretly and publish a clandestine newsletter. When the police were tipped off, supposedly by the wife of a bisexual member, Gerber was arrested but released for lack of sufficient evidence. Nevertheless, he was fired from his post office job. Surprisingly, he managed to rejoin the army and retired after World War II.

The house at 1710 North Crilly Court has been designated a Chicago landmark, and the Gerber-Hart Library, now a major gay studies archive, has been operating in various locations since 1981.

On the other hand, historians aren't likely to put up any landmark plaques in front of a couple of the town houses on that same 1700 block, according to blogger Baugher, author of *Hidden History of Old Town*, also published by The History Press. Back in the late 1930s, Baugher said, a couple named Kappy and Alexander Maley rented the house at 1716 for fifty dollars a month, but only after Edgar Crilly agreed to remodel the building and install a second bathroom.

Things are a lot more sedate on Crilly Court now than they were in the old days. *Photo by Patrick Butler.*

Noticing the town house at 1704 had an exceptionally well kept-up appearance "complete with a polished brass nameplate and door knockers," Kappy decided to drop by to introduce herself and maybe get some decorating tips, said Baugher. Baugher noted that Kappy was "courteously received by a handsome woman of a certain age and walked into a glitzy parlor where she found several young ladies all made up and lounging in their robes, albeit fairly elaborate robes, looking askance at their visitor.

"A few minutes later, Kappy realized she had not walked into just an ordinary house. She said her hasty goodbyes and left. It's not known what decorating tips she came away with," Baugher said.

Reality hit even closer to home about a week later when someone knocked on the Maleys' front door around 3:00 a.m. Alexander opened the window and saw a cab driver standing outside with three men waiting in the cab. The cabbie asked if the madam was home. Thinking it was some kind of joke, Alexander deadpanned, "Yes, but she's in bed now."

That, of course, explained all the cubbyhole rooms and the phones obviously being used by the girls to make appointments with clients, Baugher said.

While the people who lived on the block back in the 1930s and '40s weren't too pleased with their block's shady reputation, by the 1990s, home hunters were actually competing for the distinction of living in a rehabbed whorehouse, Baugher added.

Easy for them, she said. The madams and their girls were all gone by then.

# NEARLY FORGOTTEN MACHINERY MOVER, BOOKSELLER, MADE THIS LOCAL LAND OF OZ COME TO LIFE

If anyone deserves to be called the "Father of Oz Park," it's John Lenhart, the heavy machinery mover turned bookstore owner who led a 1976 campaign to get Park No. 423 at Webster and Larrabee named in honor of the turn-of-the-century children's book and its author, Frank Baum, who lived in the Lincoln Park area during the 1890s.

For about eight months, Lenhart's bookstore at 2511 North Lincoln Avenue was headquarters for a petition campaign spearheaded by Lenhart and about thirty other neighborhood residents. Together they collected nearly two thousand signatures for presentation to the Chicago Park District Board, which voted on December 14, 1976—just in time for the holidays—to name

Oz Park Tin Man, 2001. *Courtesy of the Chicago Public Library.*

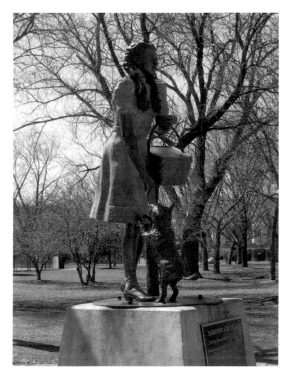

Dorothy and Toto are always on hand to welcome kids to the playground in the Land of Oz. *Photo by Patrick Butler.*

the half-completed site after Baum's most famous character. Baum spent much of his writing career turning out children's books like *The Wizard of Oz*, Lenhart pointed out to anyone who would listen.

"Parks are for kids. But how many of them are named after people you'd normally associate with kids?" Lenhart argued. Supporters began lobbying by holding Oz Festivals in Park No. 423 to honor Baum, his book and the 1939 movie starring Judy Garland.

Immediately after the park board vote, Lenhart went even further by announcing plans to launch still another campaign to raise money to decorate the park with statues of some of the leading *Oz* characters and pave the walkways with a Yellow Brick Road.

Several months later, however, the fifty-nine-year-old Lenhart took ill. He sold the bookstore on November 15, 1977, and was found dead in bed in his apartment at 2214 North Dayton Street a short time later by his landlord's son.

# Old Town—Now a State of Mind—Survived the Fire, 1960s Hippies, Changing Demographics

I f you look at a map, Old Town (originally called North Town when it was near the city limits) is generally considered the area of mostly nineteenth-century cottages, two-flats and storefronts between Ogden, Larrabee, Division, Clybourn and Clark Streets. But, cautioned Richard Acheson in the March 1967 issue of *Holiday* magazine, "it's important to stress there is no legal entity of Old Town. Old Town is where you make it."

Old Town back in the 1960s and '70s was the Midwest mecca for art, jazz and folk music, drawing singer-songwriters like Bob Gibson, Steve Goodman, Bonnie Koloc and John Prine performing at places like the Earl of Old Town on Wells Street. Probably the most successful of the clubs in those days was Mother Blues, featuring nationally known artists and groups like Spanky and Our Gang, Jose Feliciano, Odetta, Oscar Brown Jr., Bob Gibson and Chad Mitchell. Also appearing were comedian George Carlin, Sergio Mendez and Jefferson Airplane.

It's hard to tell whether the scene spawned places like the Old Town School of Folk Music or the other way around. Either way, Win Stracke started the school in an office suite at 333 West North Avenue with Fred Hamilton, who began giving guitar and banjo lessons, as well as hosting performances by well-known musicians. The only difference between then

The intersection of Clybourn, Willow and Sheffield, 1994. *Courtesy of the Chicago Public Library.*

and now is that the Old Town School has become the country's biggest community-based music school. It opened a three-story, 27,100-square-foot annex across the street from its main building at 4544 North Lincoln.

The Near North Side's second artistic pillar is Second City, an internationally known improv school and performance center at 1616 North Wells where some of the nation's leading actors and comedians—including John Belushi, Mike Myers, Bill Murray, Gilda Radner and Steven Colbert—learned their craft. Founded in 1959 by members of the Compass Players revue, started by a handful of University of Chicago undergraduates, Second City is now the country's largest improv training school, with an enrollment of thirteen thousand students a year in classrooms in Toronto and Los Angeles, as well as Chicago.

Second City's touring ensembles annually reach an estimated one million people, including fourteen thousand passengers on six Norwegian Cruise Line ships and four hundred corporate engagements. Four touring companies perform from Europe to the United Arab Emirates and Singapore.

# Class Clashes Began as Soon as the First Immigrant Groups Started Settling into the "Norte Seid"

Geography, as they say, determines history. And because it was so close to both the shopping district along North Avenue and the factories along the Chicago River's North Branch—as well as some remaining patches of open prairie—the "Norte Seid" became a magnet for skilled German tradesmen during the post-fire building boom, cabbage farmers, labor activists and political refugees.

The German community, however, was quickly split down the middle along class lines over the Haymarket Affair. After the arrest of the eight Haymarket defendants in the wake of the May 4, 1886 bombing that killed eight policemen and left sixty wounded and an unknown number of civilians dead and injured, the German community was bitterly divided. Germans on one hand were spearheading the burgeoning labor movement, while others like Police Captain Schaack were itching for a freer hand in dealing with so-called radicals. The pro-business *Staatszeitung* called for the alleged ringleaders' executions while the labor-leaning *Arbeiterzeitung* demanded their immediate release. Four were hanged and three were sentenced to life imprisonment but freed in 1892 by German-born Illinois governor John Peter Altgeld, at the cost of his political career.

Back in 1900, one in every four Chicagoans was German-born and living on the North Side, mostly in Lincoln Park and Lake View. Groups like the Social Turners, founded at Rachau's Hall at Lincoln and Fullerton, not only ran a legendarily rigorous gym program but also sponsored sports clubs and competitive bands like the Social Fife, Drum and Bugle Corps.

# German "Forty-Eighters" Battled for Freedom in the Fatherland—and Beer Here on Sunday

Among the Near "Norte Seid's" stalwarts was Lorenz Brentano, the only Chicago school board president and member of the U.S. Congress ever to have headed up a foreign country. During the 1848 revolutions, Brentano served as president of Baden long enough to have given full civil rights to Jews and introduced trial by jury and gotten himself sentenced to death in absentia for his "radical" actions when the monarchy returned to power.

By then, he'd fled to Switzerland and on to the United States, where he ran German newspapers in Pennsylvania and Michigan before coming to Chicago to practice law and start yet another paper. Returning to politics, he was elected to the Illinois legislature in 1862, became head of the school board and was named a delegate to the Republican National Convention in Baltimore.

In 1869, twenty years after his near-fatal flirtation with insurrection, Brentano got a full pardon from German authorities so he could accept an appointment from President Ulysses Grant as U.S. consul in Dresden. He returned to Chicago in 1876 and got elected to Congress but lost his bid for a second term and died in September 1891 in his home near North Avenue and LaSalle Street after years of failing health. Survivors included his widow, two daughters and a son, Superior Court judge Theodore Brentano,

but not, as a lot of people assume, the heirs of the once-major Kroch's and Brentano's book empire.

Another leading German Near North Sider, Michael Diversey, was not only an alderman, a partner in Chicago's largest brewery and a founder of St. Joseph's Catholic parish at Hill and Orleans, but he also donated the land for both the Presbyterian McCormick Theological Seminary and St. Michael's Catholic Church at Eugenie and Cleveland. Legend has it that when St. Michael's opened in 1852 as Chicago's first ethnic German parish, the name was picked in honor of Diversey's patron saint.

Diversey immigrated to Chicago in 1836 and by the early 1840s had been elected to the city council and bought a half-interest in the city's earliest brewery with money loaned by William Ogden, Chicago's first mayor. Diversey and partner William Lill started out producing nine barrels of beer a week. By 1857, their brewery at Chicago and Pine Streets (now Michigan Avenue) became the largest in the West, shipping hundreds of gallons of brew down the Mississippi and even up to the traditional Wisconsin "beer country." By 1861, the Diversey & Lill Brewery took up two entire city blocks and was turning out 44,850 barrels of beer, ale, stout and porter a year. Diversey died in 1869, two years before the Chicago fire wiped out the brewery and lost Lill $650,000.

Beer not only produced some of the Near North Side's movers and shakers but also triggered the city's first full-blown riot, started over the right to a Sunday brew, which the Germans and Irish of mid-nineteenth-century Chicago didn't take "litely." It was bought with the blood of dozens of patriots, mostly from the "Norte Seid," on April 21, 1855, when thirsty workingmen clashed with the WASP establishment led by Mayor Levi Boone, a grandnephew of backwoodsman Daniel Boone. Mayor Boone, who was also a doctor and poobah of the local Know-Nothing Party, ordered the taverns closed on the Sabbath to start making good on his campaign promise to crack down on all the "aliens" who were fast outnumbering every native-born American in the Windy City. Steady waves of newcomers had been flooding Chicago since the Irish potato famine and the 1848 revolutions on the European mainland.

Dr. Boone not only threatened to fire every foreign-born city employee but also raised the cost of saloon licenses from $50 to $300—but only for those taverns selling beer, which Boone contended no "real American" would drink. Boone then ordered the police (on St. Patrick's Day, yet) to begin enforcing an almost forgotten law requiring watering holes to stay closed on Sundays, the only day off for most immigrant workingmen.

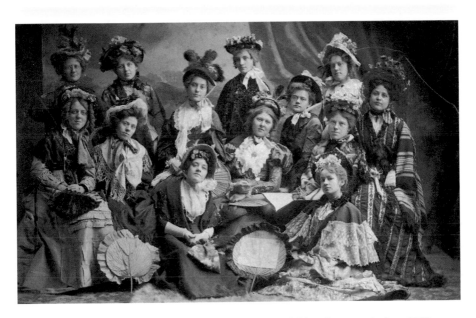

Drama club members at the Seminary Avenue Federated Church get ready for a 1902 production of *Old Maids Made to Order. Ravenswood/Lake View Historical Association Collection.*

Irate tavern keepers and their patrons met at places like Hinkel's Saloon (at what is now 623 North Wells) and the North Market Hall (across from the county jail and courthouse at Hubbard and Dearborn), lawyered up and even started their own newspaper, the *Anti-Prohibitionist.*

When the first violator of the Sunday closing law went on trial, two hundred of his supporters packed the courtroom. Hundreds more milled around outside city hall, then as now at Clark and Randolph. At 11:00 a.m., just after the defendant was found guilty, a lone drummer began a mournful roll that sent the crowds storming inside, only to be driven back to a nearby park where they regrouped and recrossed the river led by the Knights of King Gambrinus, a local German fraternal group named for the informal patron saint of brewers (and their customers).

During the battle to free nine protesters who had already been arrested, Peter Marten, a twenty-eight-year-old shoe repairman, was killed by Sheriff James Andrews after Marten allegedly shot Policeman George Hunt. Hunt later lost his arm to gangrene and was given $3,000 raised by grateful downtown businessmen in gratitude for helping save Chicago from the "Huns." He also got a cushy city job he held for the next thirty-two years.

Local newspapers reported that one protester's nose was literally bitten off during the mêlée, while another's "head was pounded to jelly." Later that week, several mysterious funerals were held on the North Side despite the "official" reports that Marten had been the only fatality.

Although between seventy and eighty demonstrators were arrested, all but fourteen were soon released. Of these, only two were ever brought to trial, but they were freed when the city decided not to press those cases.

"It seemed like a travesty of justice that in a sedition notoriously German, two Irishmen would be the only ones to suffer," chuckled historian A.T. Andreas.

Two months later, the voters rejected a proposal by Boone to ban all liquor sales on Sunday, and civic leaders urged that more Irish and Germans be allowed to join the police department (which had been founded only a year earlier with a volunteer fireman as its first chief).

And when the "Norte Seiders" held a victory parade later that year, nobody was blocking their way.

# Neighbors Dropped "Neutrality in Thought and Deed" Well before President Wilson Was Ready for It

Local men got a dress rehearsal for World War I in June 1916 when the First Illinois Field Artillery converged on the armory at 2356 North Lincoln, tripping all over one another for a chance to get Mexican revolutionary Pancho Villa, who jumped the border and killed eight U.S. soldiers and ten civilians.

Captain Frank Course, the battery commander, eventually had to call in police to remove the crowds of well-wishers, curiosity seekers and would-be volunteers, like the guy whose enraged wife came storming in, claiming he told her he'd been kidnapped and pressed into service. Another man came into the armory explaining that he was to be married that evening but would postpone the nuptials if he were allowed to sign up. Others hastily married, like Lieutenant Richard Dunne, who wed Frances Fitzgerald in a private ceremony, while Captain A.F. Siebel tied the knot with Anna Knudson at the Buena Presbyterian Church just before reporting for duty.

Not far away, at the First Cavalry Armory at 1350 North Clark Street, the nineteen-year-old son of Judge Kennesaw Mountain Landis (the future baseball commissioner) enlisted without incident.

Up in Ravenswood, however, the seventeen-year-old son of police Captain Thomas Gallery (of the same Gallery clan that later produced three

Workers at the International Harvester's Deering Plant at Fullerton and Clybourn Avenues take a break for a 1918 war bond rally. We won that one. *Ravenswood/Lake View Historical Association Collection.*

admirals, including the one who captured the German *U-505* submarine) was having trouble convincing his mother he wouldn't lose an eye or an arm. "And even if I did," the lad reportedly said, "I could go back there and get killed and it wouldn't make all that much difference."

One local officer, Major M.M. McNamee, also of the First Cavalry, refused to be left behind even after a buckboard he was riding to Union Station collapsed at Clark and Division Streets, sending the horses fleeing in panic. Though badly cut, McNamee grabbed his baggage, hailed a cab and caught up with his outfit at the railroad depot, where a medic patched him up while the troops waited to get aboard their train to Springfield.

The local boys were officially mustered into service on June 26, and by July 4, they were off to San Antonio, Texas, to join the largest U.S. force to take the field since the end of the Civil War sixty years earlier. They returned three months later without ever seeing Pancho Villa. Not that it made any

difference. Everyone believed the mobilization was purely a practice run for U.S. entry into the "Big War" in Europe.

Just the day before the troops left, Lieutenant Governor Barrett O'Hara assured officers of the First Illinois Provisional Regiment (which had been

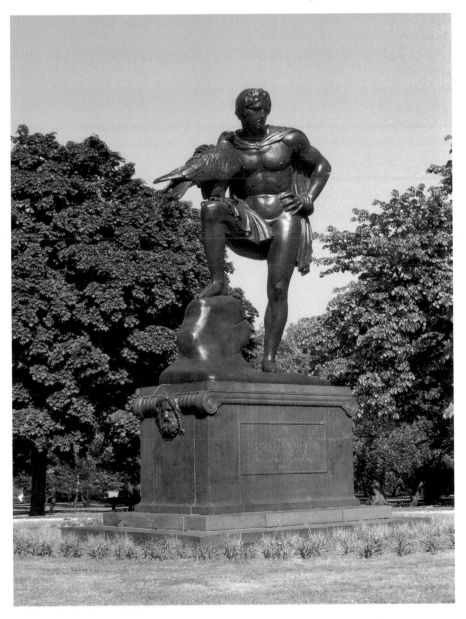

Even the Goethe Monument at Diversey and Sheridan Road wasn't spared the anti-German mania shortly after American entry into World War I. *Photo by Patrick Butler.*

left behind) that neither Pancho Villa nor even the European belligerents was all that important in the infinite scheme of things. The real trouble, he predicted, would come in not too many years from Japan.

For a time after the start of the Great War in August 1914, some Chicago Germans urged then-neutral America to side with Germany and Austria, as did Irish nationalists who hoped that victorious Central Powers would force England to pull out of Ireland at war's end. A popular song in some Lincoln Park Irish hangouts in what is now the DePaul neighborhood, sung to the tune of "O Tannenbaum," begins with the words "O Germany, O Germany, why don't you set poor Ireland free."

Irish-American congressman Frank Britten worked tirelessly to keep the United States from joining the war on the British side, as did controversial Mayor William Hale Thompson, a North Sider who once threatened to punch out English King George V if he ever set foot in Chicago. While those who knew "Kaiser Bill" understood the bravado as another way to pick up more Irish and German votes, others saw Thompson as a potentially dangerous loose cannon.

The backlash against everything German wasn't long in coming. The German Hospital, founded in 1847 as a private psychiatric sanitarium, was renamed Grant Hospital; Lubek Street became Dickens Street; a group of women organized a "Use Nothing German" club; and the nuns at St. Clement Church were reportedly asked by a group of backyard patriots to make lists of "alien" German parishioners to be turned in to the "authorities" if needed. There is no record that the good sisters complied.

# Radicals of All Sorts Usually Found Ready Audience as Europe's Troubles Found Their Way over Here

The backyard patriots needn't have worried; Lincoln Park has always had so many real radicals operating out in the open that it was never necessary to go looking for them.

Emma Goldman, the so-called High Priestess of Anarchy, was found hiding out in an apartment belonging to insurance salesman and crypto-anarchist Charles Norris on the 2100 block of North Sheffield in the days following the 1901 assassination of President William McKinley. Long before widespread use of phones (and wiretaps), the cops learned where Goldman was holed up when she sent a telegram to a friend on West Oakdale Street inviting him to come visit her. The friend never turned up. Goldman instead got a visit from detectives who had reportedly been monitoring messages out of the local Western Union office in the days before phone wiretapping.

Before Goldman was finally released about two weeks later, she had been questioned by everyone including Mayor Carter Harrison himself, who had Goldman brought to his city hall office for hours of questioning. Harrison was most interested in knowing about her acquaintance with McKinley's murderer, Leon Czolgosz, alias Fred Nieman. Czolgosz had been in Chicago for two weeks in mid-July—about two months before he shot the president on Opening Day at the Pan-American Exposition in Buffalo, New York.

The hunt for Emma Goldman, one of the alleged conspirators in the 1901 assassination of President McKinley, ended four days after the shooting here at 2126 North Sheffield Avenue. *Photo by Patrick Butler.*

Dozens of suspects were taken to the old Sheffield Avenue lockup as part of a nationwide roundup of an estimated thirty thousand suspected "revolutionaries," most of whom were quietly released as the furor died down when no assassination "conspiracy" was ever proven.

Even so, Goldman didn't win many friends when she told police, "I'm not in a position to say whether it [McKinley's assassination] was a good thing. It's up to the man who did it to decide."

For a time, Captain Herman Schueuttler of the nearby Sheffield Avenue station and others believed Czolgosz might have been recruited by radicals including Goldman to take revenge for the executions of the "Haymarket Martyrs."

Anti-Red hysteria reached fever levels on September 14 when a city council meeting was interrupted with the news that McKinley had just died of his wounds.

Aldermen called for mass deportations of "seditious aliens" and an end to emigration from countries like Germany or Russia where Reds were especially active and urged the death penalty for even attempting to kill a public official.

One alderman complained it was getting "too easy for any crank to get a handgun" and called for tighter gun controls. Some considered him the biggest radical of them all.

But then, as far back as the political refugees of the mid-nineteenth century, Lincoln Park had been a haven for émigrés like the "48ers" fleeing upheavals during modern Germany's birth pangs; the Industrial Workers of the World (IWW, or Wobblies), which had its international headquarters around Fullerton and Halsted for more than forty years; and the "Yippies" (members of the Youth International Party), who stayed in local churches and community centers during the 1968 Democratic National Convention protests.

In 1988, the once-formidable IWW, which had 100,000 dues-paying members and the ability to mobilize another 300,000 in the mid-1920s, was finally given an envelope containing some of the cremains of singer/organizer Joe Hill. The ashes had been confiscated by government agents shortly after his 1915 execution by a Utah firing squad on trumped-up murder charges. Hill's ashes had been seized as "subversive material" shortly after his cremation in Graceland Cemetery—but not before six hundred packets of Hill's ashes had already been distributed to union locals all over the world.

By the late 1960s, activism was starting to take a different turn as one-time street gangs like the Young Lords, led by Jose (Cha Cha) Jimenez,

transformed themselves into political organizations. This was in response to city planners and land speculators first pushing Hispanics into Lincoln Park from the Near North Side to make way for Sandburg Village and other middle-class developments and then forcing them out of Lincoln Park a few years later as gentrification began taking hold.

Jimenez brought the Young Lords into a "Rainbow Coalition" made up of the Black Panthers and Young Patriots that fought for low-income housing in the face of rampant gentrification, facing down bankers and landlords. Temporarily at least, they created a "People's Park" near Halsted and Armitage to protest plans to build a private health club on the site.

But in the end, money talked loud enough that Lincoln Park by the 1990s was well on its way to becoming one of the nation's toniest communities. Jimenez moved to Uptown and tried running for 46th Ward alderman. In a ward with only one thousand Hispanics at the time, Jimenez got 39 percent of the vote, losing to Chris Cohen, son of President Lyndon Johnson's Health, Education and Welfare secretary, Wilbur Cohen. Jimenez reportedly relapsed to an old drug habit and was caught not long after the election carrying a TV set out of an apartment building in the middle of the night. Jimenez cleaned up his act and, at last report, was a drug abuse counselor in Michigan.

# BACK IN 1968, EVERYONE GOT PULLED INTO A FARAWAY WAR THAT CAME HOME TO CHICAGO'S FRONT YARD

Like a lot of 1960s activists, Jimenez's ideology was formed at least partly by the "riot" in his front yard during the 1968 Democratic National Convention.

Protest preparations had been underway for some time by anti–Vietnam War activists, many of them college students (apparently more opposed to the draft than the war itself). Also on hand were all species of anarchists, socialists, Communists, middle-class revolutionary wannabes, a few black militants and adult supporters of peace candidates like Minnesota senator Eugene McCarthy who had been meeting in churches and coffeehouses across Lincoln Park since early spring.

One local resident, Philip A. (Pat) Tunis, started contacting local newspapers in April, trying to line up support for a lawsuit to move the convention out of town. When a few prominent Democrats started talking about moving the event, Mayor Richard J. Daley is said to have threatened not to support Hubert Humphrey, the Democrats' probable nominee, if the convention were moved elsewhere. When Miami was mentioned as a possibility, if only because all the necessary telecommunications facilities would already be in place because the Republicans would be meeting there earlier, lame duck president Lyndon Johnson reportedly complained that Miami "isn't really an American city."

By early summer, groups of concerned Lincoln Parkers were meeting at places like the Fullerton Avenue Presbyterian Church and St. Paul's United Church of Christ to line up places for protesters to stay, while the Medical Committee for Human Rights—made up of medical students, doctors and nurses from local hospitals—prepared to set up aid stations at places like Second City Theater, then on Clark Street just across from the park.

The week before the convention opened, the Yippies held a mock convention, electing a piglet, "Pigasis," for president, while volunteer marshals began showing demonstrators nonviolent ways of fending off billy clubs and tear gas. Reporters and other observers knew from the first day this wasn't going to be just another nonviolent exercise when a few protesters began hammering nails in tennis balls they planned to throw at the "pigs." Several hundred police officers formed a skirmish line, removed their name plates and badges and chanted "kill, kill, kill" as they moved on the crowds at the park's 11:00 p.m. closing time that was rarely enforced—until that week. Inside the park, a handful of the volunteer marshals tried without much success to keep the fleeing protesters from stampeding.

As the routed protesters poured into Old Town, bars and restaurants began closing up. Several reporters took refuge in a doorway and watched a police sergeant physically restrain one of his men from clubbing a woman on the pavement. Nearby, several "peace activists" heaved bags of feces at police, while a girl pulled down her tank top, flashing passersby. "I'd feel safer in Prague right now," a photographer said, referring to the Soviet crackdown then underway in the Czech capital.

The next day, some 1,500 protesters returned to the park and set up a barricade of tables, crates, lumber—anything they could find. The police charged three times and then started lobbing tear gas canisters at the crowd.

The following evening, some two hundred clergy members fanned out into the park as observers. Their dark suits and Roman collars weren't much protection once the fray began anew.

John Kearney, McCarthy's Illinois campaign manager who at the time lived a few blocks from the park, recalled the mêlée forty years later and how he "watched the tear gassing, yelling and fighting unfold as if it were some kind of movie."

Looking back, while most who were there now agree some protesters came looking for trouble, Kearney said it didn't help that Police Academy trainees were sent to the streets with little or no preparation.

When it was all over, there were 668 reported arrests, at least one hundred protesters treated at nearby hospitals and an estimated one thousand more

treated on the scene by Medical Committee for Human Rights teams. Police reported that forty-nine officers sought hospital treatment during Convention Week.

During the Chicago 7 trial that followed, Abbie Hoffman, one of the demonstration's organizers, said the city could have avoided all that trouble by giving the protesters Lincoln Park for the week. She commented that during the pre-convention negotiations with city hall, "I said we had no intention of marching on the Convention Hall, that I didn't particularly think politics in America could be changed by marches and rallies, that what we were presenting was an alternative lifestyle and we hoped that the people of Chicago would come up and mingle in Lincoln Park and see what we were about."

# Neighborhood Got Name from City's Biggest Park Where Everyone, Including T.R., Came for a Walk

The Lincoln Park community got its name from Chicago's largest public recreational area, 1,200 acres stretching from Ohio Street (400 north) to Ardmore Avenue (5800 north, just north of where Lake Shore Drive ends at Hollywood Avenue). Recreational facilities include 15 baseball diamonds, 6 basketball courts, 35 tennis courts, 163 volleyball courts, a golf course and any number of softball and soccer fields, public beaches, bird sanctuaries and a plant conservatory, as well as the Chicago History Museum, the Peggy Notebaert Nature Museum and a Theater on the Lake.

Ex-president Teddy Roosevelt took what was supposed to be an invigorating hike through the park on February 21, 1911, to work up an appetite for lunch at the Union League Club. Despite being handed a schedule he described as "a terror," the Great White Hunter and the hero of San Juan Hill dutifully went straight from a long train ride to Diversey and Stockton, walked half a mile and then suggested everyone go directly back to the clubhouse. "We wondered if he was really in as good shape as everyone thought until we realized he'd just gotten off the train and probably hadn't eaten for hours," a Union League member recalled years later. Once refreshed with a ham and egg snack, T.R. gave a speech on American nationalism at the Auditorium Theater; had another, bigger

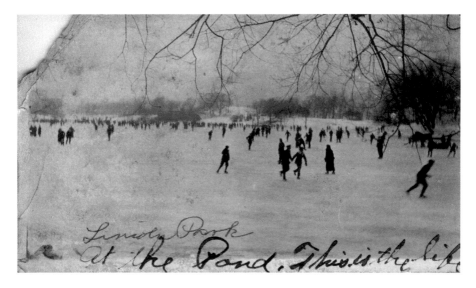

Skating was a popular pastime at the Lincoln Park Lagoon back in 1910. *Ravenswood/Lake View Historical Association Collection.*

meal at the Union League; and then met with local Boy Scouts as Jane Addams's guest at Hull House on Halsted Street.

During his whirlwind visit here, the former president called for direct election of U.S. senators (who then were being appointed by state legislatures), fortification of the newly opened Panama Canal and letting women vote. The latter was the last straw for one local paper that ran an editorial headlined "Hold It, Colonel," not far from a story on a survey showing that most Chicago-area college coeds didn't want the vote.

Roosevelt had no comment. By then, the Spanish-American War hero, future Medal of Honor recipient and Nobel Peace Prize winner had already begun a well-timed retreat back to Washington.

# Skittish Horse Got Rough Justice after Throwing Mob Boss "Nails" Morton along Riding Path

Until 1967, a bridle path with horses supplied by the New Parkway Stables on Clark near Webster ran almost the full length of the seven-mile Lincoln Park. For a time, one of the most popular features was the Sunday morning "Breakfast Ride." According to some old-timers, equestrians in formal wear would meet at the Black Forest restaurant and ride through the park to the Saddle and Cycle Club near Foster Avenue. Cowboy film and TV star Hopalong Cassidy would quarter his horse Topper at the New Parkway Stables whenever he was in Chicago, as did political kingmaker Jacob Arvey, who lived nearby and kept a string of horses at the New Parkway.

"Tough guy" actor James Cagney even drew inspiration from the revenge taken on the horse that threw and fatally kicked Samuel "Nails" Morton during one of the local gangster's routine rides through the park. Bugs Moran and his colleagues were so devastated by the pounding Nails received that Louis "Two Gun" Alterie and three assistants took the offending nag out to where Morton had been killed, finished off the horse with four shots and took the carcass to a dog food plant, informing the stable owner, "We taught that damned horse of yours a lesson. If you want his saddle, go and get it." Cagney reenacted the incident in *Public Enemy* when he took revenge on a horse that killed his buddy "Nails" Nathan.

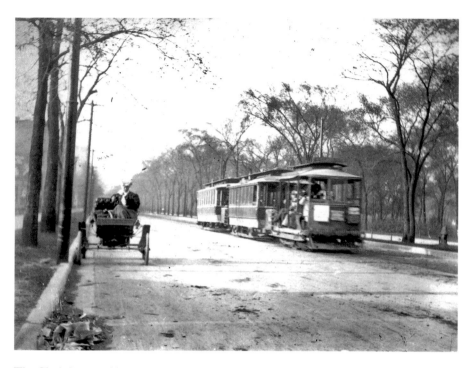

The Clark Street cable car makes its last run in the early 1900s. *Ravenswood/Lake View Historical Association Collection.*

The real-life Samuel Morton, hailed as a benefactor to the immigrant Jewish community still living around Maxwell Street, might also have been honored as "Chicago's own Sargent York" for heroic actions in France during World War I. But then, the only reason he joined the 131st Illinois Infantry in 1917 was because a judge gave him a choice between jail and the army. Morton chose the army and quickly became a lieutenant who won the French Croix de Guerre for almost single-handedly taking out a trench full of Germans and capturing twenty men. During the battle, he was wounded twice, but when it was all over, he was his squad's only survivor.

Back home, Morton killed two policemen in the Pekin Café after the cops ordered him at gunpoint to pay their tab. Morton shot and killed both men, claiming self-defense. The jury agreed.

Morton was credited with helping to invent the first "Chicago One-Way Ride" in 1921. A year later, Morton and Alterie killed a hit man who had been sent from New York to kill Dion O'Banion. Morton put the body on an eastbound train, telling Alterie, "Now the bum's headed back to New York where he belongs."

During his criminal career, Morton was believed to have personally killed at least eight men, which probably wouldn't have surprised the officer who wrote in Nails's army fitness report that "in addition to possessing natural leadership qualities and coolness under fire, Lieutenant Morton has an unusual aptitude for weapons."

# Chicago's Cycling Craze Started at Least a Century before Today's Bike-Friendly City Hall

Horseback riding began taking second place in Lincoln Park to bicycles as early as the 1890s, when Chicago was the cycling capital of the world, with at least fifty thousand "wheelmen," ten bike factories and fifty groups like the Atlas Club (which centered on Lincoln Avenue); the Lake View Bicycle Club, whose members came mostly from Orchard Street; and the Lincoln Cycling Club, whose best-known member, Joseph Gunter, won ninety-five gold medals and set a one-thousand-mile bike riding record.

Another inveterate cyclist, Fred Goetz of the 2000 block of North Pine Grove, took part in so many competitions that he only remembers being in a routine long-distance race from Milwaukee to Oconomowoc, Wisconsin, on July 2, 1881, because that was the day President Garfield was shot.

While cyclists were nearly banned from riding through Lincoln Park in 1879, they had acquired enough clout to get just about everything else banned from Jackson Boulevard by 1897.

The North Side's Viking Bicycle Club even spelled out its unabashedly political agenda in an informational brochure for prospective members: "This club and its associates control 1,500 political votes and will support candidates favorable to wheelmen and wheeling."

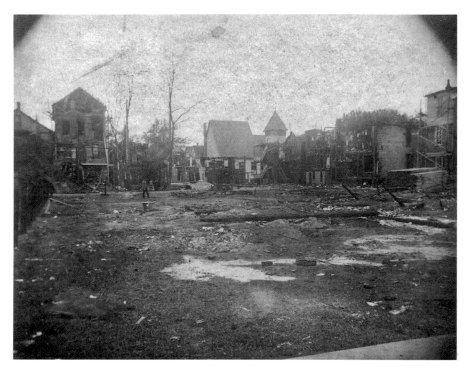

The aftermath of a 1903 fire at Seminary and Altgeld. *Ravenswood/Lake View Historical Association Collection.*

Even Carter Harrison II built his first mayoral campaign partly around his record as a long-distance cyclist yet promoted himself as "not the champion cyclist, but the cyclists' champion" and rewarded his cycling supporters with a bike path running along Sheridan Road from Edgewater to Evanston.

Romance moved out of the parlor and into the park on the proverbial "Bicycle Built for Two." While a decent cycle often ran as much as $100 (nearly ten times the average worker's weekly pay), bikes were still a lot less costly than horses.

Cycling, however, did have its risks. Chicago even had its own police cycle patrol to catch speeders—or scorchers—in the act. The unwieldy "penny farthing" models, with their five-foot-high front wheels, were often accidents just waiting to happen. And long before tennis elbow or swimmers' ear, doctors were warning against the perils of "cyclist's crouch" and "scorcher's flush" (an almost exclusively female malady caused by sun and wind burn, aggravated by sand and soot).

By 1896, 100,000 Chicagoans were turning out for the annual cycle show and its two hundred exhibits, including a custom-made, gold-plated luxury bike encrusted with diamonds.

Although the six-day bicycle races were held at the Coliseum until the 1920s, the cycling craze was all but over by the time Teddy Roosevelt left the White House, only to be revived with a new turn of the century as bikes once again took over neighborhoods like Lincoln Park.

# But Most Just Wanted to Go Ape over Bushman, Follow as Judy the Elephant Walked to Her Cage

Lincoln Park's best-known attraction is easily its zoo, one of the nation's last free zoos. Founded in 1868 with a pair of swans donated by the Central Park Board of Commissioners in New York, it's also one of America's oldest zoos.

In 1874, Lincoln Park invested ten dollars in its first animal, a bear cub that had a habit of escaping and wandering around the park at night. The first sea lions moved in before their habitat was even finished in 1889. One night, all eighteen of them apparently decided to go exploring. Seventeen of them were found the next morning in a restaurant on Clark Street. The remaining one dove into the lake and was never seen again.

Now home to more than two thousand animals seen by over four million visitors a year, the zoo's funding still comes from private donations as well as the public purse. Getting enough from that purse was a problem even back in the 1890s, when a plan to buy six gondolas for the newly completed lagoon came under fire from Alderman Mike Ryan. "Why waste the taxpayers' money buying six gondolas?" Ryan thundered during an especially memorable city council meeting. "Just buy a pair and let nature take its course."

Easily the most popular zoo residents of all time, incidentally, were Judy the Elephant and Bushman, which at 550 pounds was then the largest ape

in captivity. Judy literally walked into Lincoln Park on her own terms in 1943 when she refused to ride the flatbed truck that was supposed to take her from Brookfield Zoo. Escorted by zoo staff and motorcycle police, she instead started walking the eighteen-mile trek at 7:00 p.m., rested at Garfield Park for two hours and then hit the road again, finally reaching her new home at 2:15 a.m. Almost until her death of old age twenty-eight years later, Judy entertained a loyal legion of admirers with her inimitable "shimmy dance."

At six feet, one inch tall, Bushman was such a larger-than-life figure that when he died early on New Year's Day 1951, hundreds of grieving Chicagoans filed past his empty cage. Waiting to pay their last respects were the Reverend John Kathrein of St. Michael's Church in Old Town and baseball great Gabby Hartnett. Later in the day, Mayor Martin Kennelly and an aldermanic delegation laid a wreath below the rotunda of the zoo's monkey house.

By the end of the day, zoo director Marlin Perkins had a giant black-draped portrait of Bushman installed in the empty cage for three months of official mourning. All that was missing were pipes and muffled drums.

"It was like losing a son," recalled Edgar Robinson, who'd been Bushman's personal keeper almost since the primate's arrival from West Africa in 1930. But neither Robinson nor Near North Sider Timothy Tuomey, who'd last visited Bushman only the day before, was taken entirely by surprise by Bushman's death. After all, the twenty-two-year-old living legend had lost about eighty pounds since his health started failing six months earlier. Over the several weeks after he first got sick, 150,000 well-wishers filed past the monkey house later named Bushman Hall.

Still, by October 1, Bushman had seemingly recovered enough to roam the corridors of the Great Ape House for three hours before the largest ape in captivity was finally frightened back into his cage by a garter snake.

The last time anyone saw Bushman alive was around 8:00 a.m. on New Year's Day, when keeper Robert Jacobs saw him raise his left hand slightly, as if waving goodbye. Within a half hour, Perkins and Robinson were being summoned to Bushman's deathbed.

The worst fears of the crowd gathering outside were confirmed a short time later when a Park District ambulance took Bushman to the field museum for an autopsy. The team of doctors that included veterinarian Lester Fisher (who a decade later would succeed Perkins as zoo director) attributed Bushman's death to a heart attack and vitamin deficiency. "One of Bushman's contributions was that since his death, zoos have included

vitamin supplements in gorillas' diets," said Tuomey, a lifelong fan who held Bushman in his lap when both were kids.

Over the years, Bushman was credited with bringing more people to Lincoln Park Zoo than the total cumulative attendance at Soldier Field, Tuomey said.

At the end of World War II, even the marines voted Bushman the buddy they'd most like to have nearby for behind-the-lines "gorilla" activity, he added. After all, when push came to shove, there was no monkeying around, Tuomey said.

Except, of course, for the unconventional tryst in Lincoln Park's Farm-in-the-Zoo in the late 1980s that inspired Chicago radio personality Jonathan Brandmcir's "Moo Moo Song," about a man who was caught in the act with a calf and charged with trespassing and damaging city property, reportedly for the second time. When his case was called in the courtroom at the old Chicago Avenue (18th) District police station, several cops began mooing.

Lincoln Park Zoo also helped inspire an even more famous song and Christmas character: Rudolph the Red-Nosed Reindeer. In 1939, when Montgomery Ward's advertising editor Robert May was assigned to write a Christmas promotional brochure, he didn't have to look too far for a hero. According to a story by Peter Van Bool in *Booster* newspaper, May and his young daughter Barbara often visited the zoo, where the reindeer were the girl's favorite animals.

Inspired by both the reindeer themselves and the "Ugly Duckling" story by Hans Christian Andersen—who has his own statue in Lincoln Park not far from the reindeer habitat—May created the legend of a misfit deer whose glowing red nose made him an unexpected hero one foggy Christmas night when Santa asked Rudolph to guide his sleigh. May got his friend and colleague Denver Gillen to visit the zoo and make sketches of a reindeer that helped convince even the Ward's executives who were dubious about making a role model out of a red-nosed reindeer at a time when red noses were often used in jokes about drunks.

That Christmas, Ward's gave out more than two million copies of the free booklet introducing Rudolph to the public during the war. May himself became an instant celebrity. In 1947, the next year the booklets were distributed (none were printed for several years because of a wartime paper shortage), more than six million copies were given out. The appreciative company gave May the copyright to the story, and the rest, as they say, is history.

May's brother-in-law, songwriter Johnny Marks, wrote a song about "the most famous reindeer of all" that got recorded by singing cowboy Gene

Autry, who had gotten his first big break on Chicago's own WLS-Radio barn dance. Marks went a step further by writing "Run Rudolph Run" for rock-and-roll superstar Chuck Berry and still more Rudolph-related songs for the 1964 Rankin/Bass Productions Rudolph NBC-TV special, sponsored by General Electric.

# New Uses Continue to Be Found for Old "Fresh Air Sanitarium," USO Site along Lakefront

Today's Theater on the Lake at Fullerton and Lake Shore Drive may be the ultimate in repurposing long before anyone ever used the word.

Built in 1920 as the Chicago Daily News Fresh Air Fund Sanitarium, it replaced two earlier open-air "floating hospitals" in response to mounting concerns about the health of the growing number of Chicago slum children living with polluted air and poor medical attention. The first of two open-air floating hospitals opened in the 1870s on 150 concrete pylons connected to shore by a ramp. About thirty years later, it was replaced by a new building on a man-made "Picnic Island" surrounded by a lagoon on the west and the lake on the east.

Back then, doctors believed that lakefront breezes going through those wooden shelters would help cure babies and children suffering from tuberculosis and other common respiratory diseases. In 1914, *Chicago Daily News* publisher Victor Lawson launched a campaign to build and run a more permanent facility on a new landfill instead of stilts. He hired Dwight Perkins, a social reformer as well as an architect whose credits included Lincoln Park's Lion House, Café Brauer and the North Pond Café.

The new Prairie-style building had 250 basket cribs and hammocks and offered free health services, milk and four meals a day to more than thirty

thousand children every summer until the sanitarium closed in 1939. The *Daily News* invited families to bring their sick children to the new facility while asking readers to help fund the program with loose change dropped in "Charity Globes" located across the city.

Almost daily, stories in Lawson's paper told about youngsters whose health improved after just one visit. A 1931 annual report issued by the *Daily News* noted that "to this haven of rest and health have come an average of 400 children a day throughout the summer months."

A horse-drawn wagon (later replaced by a car) brought mothers and their children to the day sanitarium from the Halsted Street streetcar stop.

After the sanitarium's closing in 1939 and the onset of World War II, the USO took over the building to serve military personnel from Fort Sheridan and the Great Lakes Naval Training Center. When the war ended, the Chicago Park District used the building for barn dances and later for its growing summer theater program.

In late 2014, Mayor Rahm Emanuel and Park District superintendent Michael Kelly announced plans to convert the Theater on the Lake into a

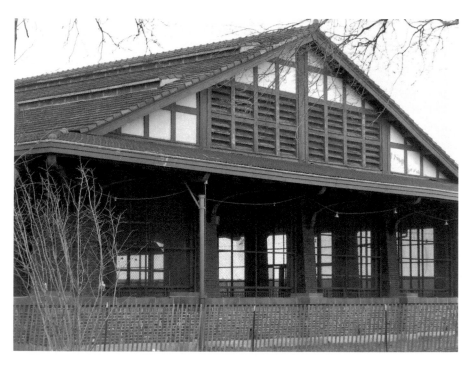

The Theater on the Lake at Fullerton and the lakefront has been a health spa for urban babies and youngsters, a USO and now a theater. *Photo by Patrick Butler.*

year-round facility hosting stage plays and other cultural events. According to the mayor's office, plans included a café and a new four-hundred-seat theater space, a new dressing room, a place for special events and a new heating/cooling system to make year-round operations possible. The renovation was planned in conjunction with the U.S. Army Corps of Engineers' Shoreline Protection Project and will include a new drop-off area for cars and six acres of new landfill.

While funding has yet to be worked out, Emanuel said that while he was still a congressman, he got federal money earmarked for Theater on the Lake that had since been building interest and added that the Park District would be receptive to any and all proposals. Depending on the ideas adopted, "the project could take a variety of funding and revenue approaches, but in almost every potential case it will be a public/private partnership."

During the renovation, Theater on the Lake events were to be relocated to other parks around the city.

# AFTER MORE THAN A CENTURY, BODIES STILL KEEP TURNING UP IN LP'S SUPPOSEDLY EMPTY GRAVEYARD

This area was originally called Cemetery Park because from 1843 until after the Civil War, Lincoln Park was where most Chicago burials were held. The site was subdivided into a potter's field for indigents, Catholic and Jewish graveyards and the main city cemetery. After health commissioner Dr. John Rauch recommended in 1858 that the bodies be moved elsewhere, warning that having putrefying corpses so close to the lake posed a serious health hazard, Lincoln Park was slowly converted into recreational space north of North Avenue and residential development south of North Avenue.

Among the dead were five thousand Confederate POWs who were moved in 1895 to a one-acre site in Oak Woods Cemetery on the South Side, not far from the Camp Douglas prison camp where they had died between 1862 and 1865. The mass grave and monument were paid for by Confederate veterans and Chicago sympathizers. Some bodies are believed to remain in Lincoln Park today under the baseball diamonds.

Other remains have turned up piecemeal over the years. In the 1980s, construction crews widening LaSalle Drive stumbled across the bodies of two women whose bones were immediately turned over to the medical examiner's office, which ruled the ladies probably died during an 1850s cholera epidemic.

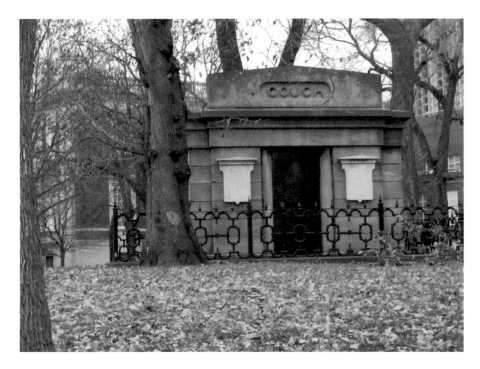

Who's buried in Couch's tomb? Estimates range from one (Ira Couch himself) to as many as nine. Nobody knows for sure. *Photo by Patrick Butler.*

Two grave sites still visible are the Ira Couch Mausoleum behind the Chicago History Museum at Clark and North and David Kenneson's resting place a few hundred yards east of Clark and Wisconsin. The Couch tomb reportedly remained untouched because the family refused to allow the remains to be moved. The Couches argued that while they had donated some of the land to create the cemetery in the first place, they retained ownership of the land under the family tomb. According to some stories, they sued the city in 1865. A court supposedly ruled that graves belong to the dead, not the living. Other local historians insist the case never actually got to any court.

So why is the one-hundred-ton tomb still in the park nearly a century and a half after almost all other bodies were supposedly transferred to other cemeteries? It's a mystery, as is the mausoleum's actual number of occupants. Some say there may be as many as nine bodies entombed there, including Couch, some family members and a friend. Others say only Couch himself is in the mausoleum, while *Graveyards of Chicago* author Ursula Bielski says nobody's there anymore and that even Ira Couch is buried in the family plot

Here lies the last survivor of the Boston Tea Party? Maybe not. But that didn't prevent the city from giving David Kennison a full state funeral when he died a pauper in 1852. *Photo by Patrick Butler.*

at Rosehill Cemetery. She claims that it would take an act of the city council to allow the tomb to be opened at this point. Bielski also questions estimates that there may still be 1,500 bodies buried in what is now Lincoln Park. "It could be as many as 15,000," she said. We may never know.

David Kennison, on the other hand, was less a mystery than the ultimate Chicago sting. If he was to be believed, Kennison—who died here in Chicago supposedly at age 115—was the last survivor of both the Boston Tea Party and the Revolutionary War and outlived four wives and most of his twenty-two children.

His February 1852 funeral was the biggest Chicago had ever seen up to that time, complete with the muffled drums of military bands, a fire department honor guard, the mayor and the entire city council, delegations of clergy, leaders of fraternal and civic groups and cannon salutes along the processional route from a packed Clark Street Methodist Church. The only problem was that he would have had to have been nine years old at the time of the Boston Tea Party and twelve when the Revolutionary War

started in 1776, noted Charles Lewis in a 1914 talk before suburban Oak Park's Borrowed Time Club. Nevertheless, Kennison claimed to have fought the war's opening battles at Lexington and Concord and later served as a dispatch rider for General George Washington himself. "Apparently nobody ever questioned his ability to attend the surrender at Yorktown [Virginia], while at the same time he was a captive of Indians in New York state," historian Albert Overton mused.

At war's end, Kennison settled on a farm in Vermont but got so bored that he rejoined the army just in time for the War of 1812 and found himself posted to one of the country's most remote frontier outposts, Fort Dearborn, at a place the Indians called Checagou. To hear him tell it, Kennison would probably have been killed in the Fort Dearborn massacre if he hadn't been sent on what seemed like a far more dangerous mission to Fort Detroit, which was expecting an imminent British attack from Canada.

Kennison claimed to have been wounded only once—in the hand—in combat but cracked a collarbone and broke both legs when he fell from a tree trying to hide from some Indians, broke both legs when a cannon exploded during a parade and suffered a deep scar on his forehead when he was kicked by a horse. Nevertheless, if Kennison is to be believed, he served into his eighties, which would have made him the oldest enlisted man in the history of the U.S. Army.

But none of these inconsistencies kept Chicago from embracing the old soldier who refused to "just fade away," as the barrack's ballad goes. Chicago embraced Kennison as a living link to the founding fathers. The Daughters of the American Revolution's David Kennison chapter once held gatherings at Kennison's grave site on Memorial Day, Flag Day, George Washington's birthday and the anniversary of the Boston Tea Party.

In August 2003, more than six hundred people met at Kennison's grave site for a rally sponsored by the Tax Reform Action Coalition, a grassroots group pressing for a cap on skyrocketing property taxes. After all, weren't runaway taxes one of the main reasons for the Revolution in the first place, asked TRAC founder Barb Head, who wasn't all that concerned upon learning that Kennison may not have been all he claimed to be.

Sometimes symbols are just as important as hard facts, she explained with a wink.

# Old Viking Ship Gone, but Not Forgotten, as Fans Continue Their Long Search for Its New Home

Another very important Lincoln Park symbol—the Viking ship kept on display near the zoo's duck pond from 1919 to 1998, when the Chicago Park District ordered it moved to make way for a major zoo expansion—was rowed here from Norway as part of the 1893 Columbian Exposition.

The seventy-six-foot-long exact replica of a Viking ship unearthed only a few years before Chicago's World's Fair made the 4,500-mile Atlantic crossing in twenty-eight days to show how Norsemen got to America at least five hundred years before Christopher Columbus. The twelve-man crew commanded by Captain Magnus Andersen, a Norwegian newspaper publisher and yachtsman, used only oars and sail, guided by a sextant, compass and barometer. The only time they were in any real danger was after landing in New York, when they were mobbed en route to a banquet in their honor by angry Italians who thought the latter-day Vikings were trying to discredit Columbus.

Chicago mayor Carter Harrison I took command of the ship when it arrived on July 12 at about the same time replicas of Columbus's three ships were being towed from Spain because they weren't seaworthy enough to make the trip on their own. One of those ships, moored off Lincoln Park in the early 1920s, was eventually lost through neglect. The other two were

This Viking ship replica, sailed here as Sweden's gift for Chicago's 1893 Columbian Exposition, has been looking for a permanent home since 1994. *Ravenswood/Lake View Historical Association Collection.*

berthed on the South Side near what is today LaRabida Sanitarium. They, too, perished from neglect.

For a time, it looked like a similar fate awaited the Viking ship, which remained in the Jackson Park lagoon for about ten years after the fair before being moved to Lincoln Park Zoo.

Because the Park District allocated no money for the ship's upkeep, a Scandinavian group did what it could. But by the late 1970s, the ship—exposed as it was in an open shelter—was not only encrusted with decades of rock-hard pigeon guano but was also clearly showing signs of serious weather damage. In 1978, a Viking Ship Restoration Committee began raising funds and looking for a new home for the ship. It still hasn't found one. The Museum of Science and Industry—which already hosts the *U-505* German submarine captured by North Sider Dan Gallery—and Navy Pier both got serious consideration, but they weren't interested.

By 1993, however, the Chicago Park District told the committee the Viking ship would have to be moved to make room for a planned Lincoln Park Zoo expansion. The ship was moved first to a warehouse in suburban

West Chicago and then to Good Templar Park in Geneva, Illinois, with the ship's dragon head and tail left for safekeeping at the Museum of Science and Industry.

Although work on the ship continues with funds from American Express and the National Trust for Historic Preservation, even the most optimistic rescue committee members don't expect the well-traveled landmark to find a permanent home anytime soon.

In 2007, the Viking was declared one of the state's ten most endangered historic sites by Landmarks Illinois, a statewide preservation group.

# But a Copy of the World's First "Pleasure Wheel" Is Still Making Its Rounds Nearby at Navy Pier

Unfortunately, it's too late to save what would have been another important local landmark: the world's first Ferris wheel, which, like the Viking ship, was built for the 1893 Columbian Exposition. It was reassembled at Clark and Wrightwood in 1896 to be part of what its owners hoped would be a major restaurant and amusement complex.

For the next seven years, an estimated 500,000 people paid $0.50 each to ride the 260-foot "Pleasure Wheel," as it was called at the time. But even a $250,000 gross wasn't enough for the promoters to meet expenses after neighborhood residents voted the area dry, objecting to "another example of undesirable industrialization invading a residential district."

The two-hundred-ton brainchild of Pittsburgh engineer George Washington Gale Ferris Jr. was powered by two one-thousand-horsepower steam engines able to move up to 1,440 people during each twenty-minute ride. It had been shipped to the World's Fair from five different factories in 175 freight cars. The axle alone weighed fifty-six tons and at the time was the largest single piece of steel ever forged.

One of the riders, the young W.E. Sullivan, made notes of the design and later founded the Eli Bridge Company, which eventually became the world's largest Ferris wheel manufacturer.

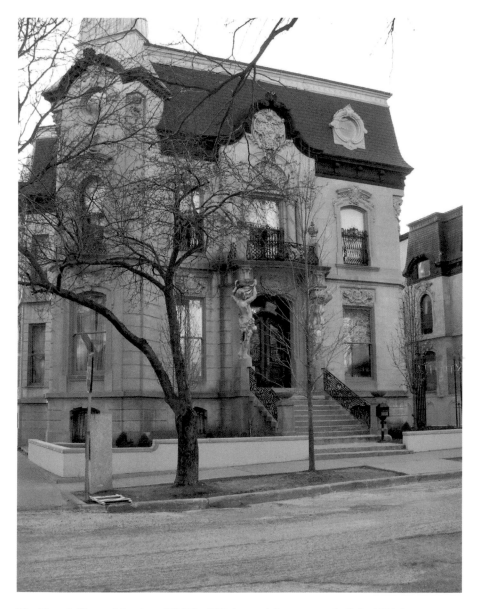

The Francis Dewes Mansion, 503 West Wrightwood Avenue, was built in 1893 for a German beer baron and has been used for everything from weddings to gay movie shoots. *Photo by Patrick Butler.*

When the exposition closed, it took eighty-six days and $14,000 to dismantle the fair's star attraction and move it to the North Side, near Clark and Wrightwood. After the dry vote campaign ironically led by beer baron

Francis Dewes, an opponent of local option drives in other parts of the city and owner of a landmark mansion that still stands a few blocks away, the wheel was again dismantled and shipped to the St. Louis World's Fair, where it barely made expenses.

But this time there would be no second chances. The big wheel was auctioned off in a distress sale that brought the owners only $1,800. In May 1906, ten years after its inventor died broke and discouraged by interminable financial problems, Ferris's wheel was brought down once and for all with two hundred pounds of dynamite.

In a final touch of irony, early imitator W.E. Sullivan had far better luck with his Ferris wheels. Of the 1,200 his foundry had made since 1903, all but fifty were reportedly still in use throughout the world as of the early 1970s.

Fortunately, 102 years after the original Ferris wheel went up on the Columbian Exposition Midway, a replica was unveiled at Navy Pier. But it wasn't quite an exact replica. Big as it looks, it's only half the size of George Ferris's brainchild.

# Long before the Yuppies, Clark and Diversey Area Was Home to Union Recruits, Confederate POWs

A quarter century before the Ferris wheel came to the North Side, German societies from all over North America converged on Wright's Grove, near today's Wrightwood Avenue, for one of the biggest songfests ever staged anywhere before Woodstock.

But it wasn't the first time the sound of hundreds of men singing could be heard where the Clark-Broadway-Diversey intersection is now. In the mid-1860s, neighbors could clearly hear the strains of "Dixie" and a medley of southern folk songs coming from the Confederate prisoners of war lucky enough to have avoided being shipped to the much larger Camp Douglas on the South Side, perhaps charitably known as the "Andersonville of the North," where five thousand Rebels died of disease in three years.

Bought in 1860 by land speculator Edward Wright, who thought the site had future residential development possibilities, the tract was taken over by the Union army the next year for use as a recruit depot for the mostly German and Luxembourger volunteers from Lake View Township. (Irish troops, who together with the Germans formed the backbone of the Union forces, according to more than one senior officer, were trained near their homes on the South Side.)

Camp Fry, named in honor of General Jacob Fry, one of the promoters of the early Illinois and Michigan Canal, was first used as a training center for the 132$^{nd}$ and 134$^{th}$ Volunteer Infantry Regiments. In 1864, the camp was converted into a military prison after the last of the trainees shipped off to garrison duty in Kentucky. By the end of the war, enough of a settlement had developed to give Wright's Grove its own post office.

Today, about all that remains of Wright's dream is Wrightwood Avenue.

# How Dwight L. Moody Went from Selling Soles to Saving Souls—Some Say He's Still Doing It

The Near North Side's other well-known ecclesiastical powerhouse with a past is the Moody Church at Clark and North, founded by a fifth-grade dropout who was never ordained. Yet by the time he died, Dwight L. Moody had preached to an estimated 100 million souls. And that was before radio or television.

Although he made $5,000 in eight months selling shoes, shortly after arriving in Chicago from Massachusetts in 1856, Moody's interest quickly turned from soles to souls. By 1859, he had started a Sunday school for slum kids at Chicago and Wells. The overflow crowd went to North Market Hall on Hubbard Street. En route to Washington, President-elect Abraham Lincoln spoke with the youngsters and assured them that if they worked diligently, studied hard and lived by the Bible, they also could achieve what he had. During the Civil War, Moody led revivals for both front-line Union troops and Confederate POWs being held at Camp Douglas on the South Side.

He later headed the YMCA's Chicago branch, was a leading fundraiser for Chicago fire victims and by 1873 had teamed up with organist Ira Sankey for a two-year preaching tour of England, Scotland and Ireland. Together, Sankey and Moody (despite being tone deaf) produced several of

The Moody Church at Clark Street and North Avenue was built in 1924 and seats 3,740 worshippers. *Photo by Patrick Butler.*

the late nineteenth century's best-selling hymnbooks and are credited with popularizing early gospel music in the white community.

But Moody had far more serious concerns than the clergy of that day's usual condemnation of alcohol, tobacco, the theater, teaching evolution, Sunday newspapers and store hours on the Sabbath. "Character," he once explained, "is what a man does in the dark."

His Illinois Street Church became today's Moody Church. And his revivals during the 1893 Columbian Exposition drew nearly two million listeners, reportedly making him the most popular preacher of that time.

On the morning of October 8, 1871, Moody told a crowd at the Farwell Hall YMCA, "I'll give you a week to go and see what you can do with Jesus Christ," not knowing that some of his listeners would be dead by the next morning. The Chicago fire's deadly wrath was marching north, destroying everything in its path, including Moody's State Street home.

In 1889, he founded the present Moody Bible Institute at Chicago and LaSalle, possibly the first missionary school to get its own radio station, film production studio and airplane pilot training program. The new school

Newberry Library president David Spatafora (right) presents the Dill Pickle Award to Reverend Edwin Lutzer, senior pastor of Moody Church. Lutzer won that year's Bughouse Square soapbox contest. *Photo by Patrick Butler.*

trained what Moody called "gap men," ranked between clergy and laity, to do street mission work. Since then, the school has reportedly trained half the airborne Protestant missionaries in the world today and runs the largest fundamentalist publishing house in the country.

Accomplishments like that wouldn't have surprised Moody in the least. "Someday you'll read in the papers that I'm dead. Don't believe it for a minute. I'll be more alive than ever. And I shall have left behind some grand men and women," he once said.

Moody, in fact, seemed to attract "grand men and women" even after death. In 1912, John Harper, a Scottish preacher, was selected to take over the pulpit at Moody Church and booked passage for his daughter, niece and himself on the White Star Line's new" unsinkable" luxury liner *Titanic.* His daughter and niece were rescued. Harper died along with 1,516 other passengers and crew—but not before he was seen preaching on the sinking ship and even comforting fellow victims as they struggled in the icy waters.

# CHICAGO CAN THANK A ONE-TIME CONFEDERATE FERRYBOAT CREWMAN FOR LINCOLN TREASURES

If Charles Gunther hadn't been briefly captured by Union soldiers in 1862, the Chicago History Museum (CHM) would probably never have become the home of Abraham Lincoln's carriage, his deathbed, a towel soaked with Lincoln's blood—and the supposed skin of the serpent that tempted Adam and Eve and the mummified corpse of Moses's foster mother. Although the last two items are assumed to be phony, the treasure-trove from the "Candy Man's" collection was once described by CHM document director Libby Mahoney as "the backbone of the museum."

The twenty-five-year-old German-born ice merchant and riverboat purser was ferrying Confederate supplies when he was detained by federals near Van Buren, Arkansas. Released a short time later, Gunther headed north to Chicago, where he eventually became one of the city's largest candy purveyors, credited by some with introducing caramel into the United States.

With well-heeled customers like Bertha Palmer, Gunther soon began traveling the country, collecting all kinds of memorabilia ranging from shrunken heads to hundreds of artifacts from the recent Civil War for display in his new factory on South State Street. Among the once-proud acquisitions on display there and later in the Chicago History Museum in Lincoln Park was the so-called Putnam Chain, nine hundred pounds of iron

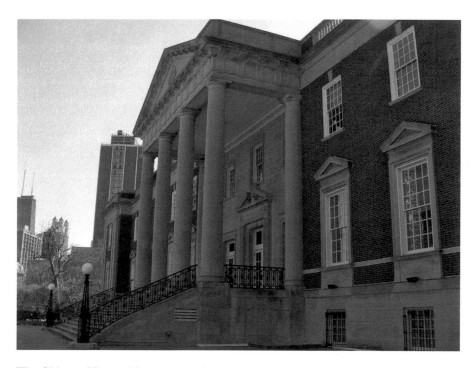

The Chicago History Museum contains everything from the bed Lincoln died in to what was once believed to be the skin of the snake that tempted Adam and Eve. *Photo by Patrick Butler.*

links (named for Revolutionary War general Israel Putnam) once believed to have been one of several giant chains strung across the Hudson River to block the approach of British ships. Once displayed near the front door of the museum, the chain was later all but hidden behind some shrubbery on the east side of the building after its authenticity was called into question by both the Smithsonian Institution and the curator of the West Point Museum.

But apparently the sky was the limit for the enthusiastic Gunther, who at one point thought about buying an Egyptian pyramid, Independence Hall and the house where Jesse James was shot and reassembling them here in Chicago. Gunther actually did buy the notorious Libby Prison in Richmond, Virginia, and had it dismantled and shipped brick by brick to the 1400–1600 blocks of South Wabash in 1889. There, he built a Civil War museum that closed a decade later as interest started waning.

He replaced that with the Coliseum that included one of the walls of the infamous prisoner of war building. That amphitheater hosted the 1896 Democratic National Convention where William Jennings Bryan gave

his "Cross of Gold" speech. It was also the site of Theodore Roosevelt's Progressive Party convention in 1912 and five consecutive GOP conventions from 1904 through 1920, as well as rock concerts, roller derbies and professional wrestling matches from the 1960s until it closed in 1971. And it was here that Aldermen "Bathhouse" John Coughlin and Michael "Hinky Dink" Kenna held their 1st Ward Ball, an annual political fundraiser that typically raked in at least $50,000 from crooked police, pimps, prostitutes and aspiring politicians. The last of the legendary soirees was in 1908, when it was closed down by Mayor Fred Busse. No stranger to politics himself, Gunther served a term as 2nd Ward alderman from 1896 to 1900, followed by a year as city treasurer.

But it was his relentless art and curio collecting that apparently held the nationally known connoisseur's greatest interest. In addition to being a Chicago Historical Society board member for twenty years, Gunther was also a trustee of the Chicago Academy of Sciences and the Art Institute.

Gunther initially offered to donate his Civil War collection to the city, provided a fireproof building could be built to house it. But when the construction funds were never appropriated, the collection was eventually sold after Gunther's death to the Chicago Historical Society.

Today's Chicago History Museum at 1601 North Clark Street has in recent years become much more than a world-class research library with one of the country's best collections of Lincoln and Civil War memorabilia. Where else would you find gay and lesbian memorabilia and a 1978 Chevrolet Monte Carlo not far from the Pioneer, Chicago's first locomotive back in 1848, and the first El car, which carried visitors to the 1893 World's Fair?

Among the CHM's estimated twenty-two million items are boots from a Gaslight era "lady of the evening," Hugh Hefner's "Little Black Book," Scottie Pippen's jersey worn during the Chicago Bulls 1998 championship season, a baseball signed by Babe Ruth during a 1933 All-Star game, a piece of the rope used to hang abolitionist insurgent John Brown, a cluster of melted marbles from the Chicago fire, Illinois governor Henry Horner's top hat, an Oscar Mayer tin from 1960, slave shackles and a prehistoric stone axe head. And there's a canceled check for Martin Luther King's $5,000 speaker fee for appearing at a 1964 civil rights rally in Soldier Field.

Clearly, what gets shown there is no longer determined by a board made up of the well heeled and well entrenched who often had a stake in protecting the status quo, or at least the reputations of their forebears. Special exhibits and events in recent years have included once

uncomfortable topics like the Haymarket Affair and its effect on the labor movement and a look back at the 1968 protests. An exhibit, "Facing Freedom," addresses the successful efforts to unionize Pullman railroad porters and California farm workers; the women's suffrage movement; and the American Indian resistance at Wounded Knee, South Dakota, in the 1970s. On the other hand, there have also been recent major exhibits like "Styling on the Magnificent Mile," a look at contemporary fashions, and "Vivian Maier's Chicago," focusing on an obscure Rogers Park photographer and her burst into posthumous fame.

# STANDING LINCOLN STATUE HAD A STARTLING START BUT STILL RANKED AMONG AMERICA'S BEST STATUES

Chicagoans visiting London can expect to do a double take when they exit the front door of Westminster Abbey. Just across the street they'll see an exact full-scale replica of Augustus Saint-Gaudens' twelve-foot-tall *Standing Lincoln* they thought they'd left behind outside the Chicago History Museum in Lincoln Park. No, it's not a hallucination. The British replica was made from the same mold created by sculptor Augustus Saint-Gaudens.

Robert Todd Lincoln, the sixteenth president's son, was U.S. ambassador to England when his son Abraham "Jack" Lincoln II suddenly died in London in 1890 at seventeen. Two years earlier, Jack had unveiled the original bronze *Standing Lincoln* in front of ten thousand spectators at North Avenue and Clark Street, just south of LaSalle Drive. In 1920, when members of several London congregations created a fund to erect a monument to the "Great Emancipator" and asked Robert Todd Lincoln for guidance, the president's only surviving son requested they use the *Standing Lincoln* version.

Imitation—one of the highest tributes—continued. In 1964, the Park District granted permission for another full-scale replica of the *Standing Lincoln* to be made and presented by President Lyndon Johnson to the people of Mexico to commemorate the anniversary of that country's "Second War

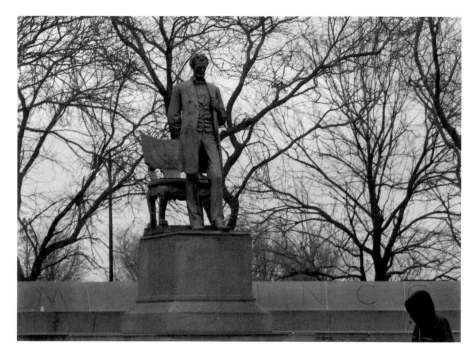

The *Standing Lincoln* statue has been replicated in England and Mexico since it was dedicated in 1887 before an estimated ten thousand spectators. *Photo by Patrick Butler.*

for Independence." Like the original in Chicago, this one stands in Parque Lincoln (Lincoln Park) in Mexico City.

Saint-Gaudens' project was underwritten by Chicago lumber dealer Eli Bates, who left $40,000 in his will for a Lincoln monument in Lincoln Park. The Irish-born Saint-Gaudens saw Lincoln en route to Washington for his 1861 presidential inauguration and again four years later when the martyred president lay in state under the capitol dome. *Standing Lincoln*, incidentally, wasn't Saint-Gaudens' only statue of the "Savior of the Union." In 1920, *Sitting Lincoln* was unveiled in Grant Park thanks to a $100,000 donation from industrialist John Crerar.

From the very start, *Standing Lincoln* was hailed by historians, art critics and tourists as one of the finest Lincoln statues anywhere in the world. The same year the statue was unveiled, the *New York Evening Post* was praising Saint-Gaudens' work as "the most important achievement American sculpture has yet produced." Describing the statue nine years later, Chicago sculptor Lorado Taft said, "One stands before it and feels himself in the very presence of America's greatest soul."

The praises continued even during the statue's October 22, 1887 dedication. "We see him in this beautiful image of bronze above us which the sculptor helps us recall the real presence," said Thomas Withrow, a lawyer who rode the court circuit with Lincoln a half century earlier.

Other plaudits came from T.F. Withrow, head of the Monument Fund, as he presented the statue to the Lincoln Park commissioners. "As long as the flowers shall bloom among these trees and the waves of Lake Michigan break on the shore this figure will preserve the memory of the patriot and martyr whose firm adherence to his convictions has made every man a free man and preserved the union of these states," Withrow said.

Despite everyone's best efforts, the dedication ceremony didn't go off quite as expected. A woman was thrown from a carriage and another jumped to safety when the First Regiment started to play "Hail Columbia" and artillerymen began firing a thirty-eight-gun salute, startling the horses. Neither woman was seriously hurt, but the cannoneers immediately ceased fire.

*Standing Lincoln* was rededicated and given landmark status 115 years later—this time before a much smaller crowd made up of city officials led by 43rd Ward alderman Vi Daley and some children on recess from the nearby Lincoln Park Cultural Center.

# Was It Environmentalism or "Elitism" That Left Lincoln Park Gun Club Dead in the Water?

After seventy-nine years as a lakefront institution, the Lincoln Park Gun Club—officially known as the Lincoln Park Traps—was itself shot down by irate neighbors and environmentalists in 1991. The skeet and trap shooting sanctuary was founded by some of Chicago's leading citizens, including wienermeister Oscar Mayer, jeweler W.C. Peacock, big gum gun P.K. Wrigley and Montgomery Wards czar Sewell Avery. "March King" John Philip Sousa himself directed the band at the clubhouse dedication at 2901 North Lake Shore Drive.

Club members popped away in peace at clay pigeons and occasional waterfowl until February 1991, when Illinois attorney general Roland Burris sued the club, charging that it was polluting the lake with lead shot and plastic wadding from shotgun shells and clay pigeons. "The law is clear. It says it is illegal to discharge any kind of material in the lake," Friends of the Parks director Erma Tranter told a *New York Times* reporter back in 1988, when environmental and neighborhood groups were already pressing the club to move away from the lakefront. At this point, estimates put more than 400 tons of lead and fragments of millions of targets at the lake's bottom.

The club's lawyers didn't deny their client was putting foreign substances in the lake but argued the law is too broad because it doesn't just ban pollutants.

"It forbids putting a sweaty baby, a brick of gold bullion or Perrier water into the lake," said former 46th Ward alderman Chris Cohen, one of the club's attorneys. The real question, club attorneys argued, was whether lead shot, pieces of clay or bits of wadding harm the lake's water quality and pose a serious environmental hazard.

Tranter said the lead shot and even the clay pigeons are toxic because the clay targets are made with toxic petroleum pitch. On the other hand, the Illinois Environmental Protection Agency (IEPA), which had earlier warned the gun club that it might be violating state law, admitted during hearings it wasn't sure how serious the problem in the lake actually was. "We don't know if it's a serous problem or not," IEPA lawyer Jose Gonzales conceded.

"Compared to a lot of the steel mills and marinas and other facilities along the lake, we don't think of ourselves as a polluter," said club member (and lawyer) Fred Lappe. Nevertheless, he told a reporter, "we intend to cooperate as best we can."

The club, which was open to the public, was funded by dues and fees from its four hundred members, who ranged from blue-collar gun owners and police officers to corporate executives who paid fourteen dollars for a half hour's worth of ammo and clay targets. Among the club members and general public who also used the club were a few aldermen, which some believed was one reason behind the city council's non-binding resolution asking the Park District board not to do anything before state and federal environmental agencies made their own recommendations.

It's not about pollution, it's really about guns, said club president Rufus Taylor. "There's a group of people that's against guns, that's all. They would rather not see a gun club in Lincoln Park. They're against the shooting activity and they're just using the environment as an excuse."

"The gun club keeps camouflaging the issue," Tranter told *Chicago Reader* reporter Ben Joravsky in 1988. "They say they are integrated—that they have blacks, Chinese, Koreans, Japanese, Vietnam vets and women—and that's not the issue. They say people who oppose them are elitists. And that's not the issue. They say it's all about guns, and that's not the issue. The real issue is that they are violating the laws that are supposed to protect the lake from pollution. Any other issue they raise is a fraud intended to divert attention from that fact."

Park District officials and environmental law experts like Andrew Perellis said boaters and bathers frequently complained of shell waddings washing up on beaches and docks, Park District lawyer Nancy Kaszak said. And

"in this case, the gun club is violating eight [antipollution] statutes with maximum fines in the thousands of dollars.

"All these fines could be imposed on us, because as the owners of the property, we were essentially permitting the gun club to dump into the lake," Kaszak told the *Reader.*

To protect the Park District and the public, Kaszak and Jesse Madison, the agency's executive director, recommended revoking the gun club's permit to operate on park property.

The real issue here wasn't the environment or apparently even guns at that point but "elitists" with "socialistic tendencies," Taylor said at a press conference organized by Chris Cohen, the club's newly hired lawyer.

Now it was the Park District—not the gun club—coming under fire as major papers like the *Chicago Sun-Times* warned, "Don't let purists control the lakefront," while *Crain's Chicago Business* said park officials are "beginning to look like a lot of spoilsports.

"What's next on their hit list? Tennis? Golf? Bird watching? Maybe they'll go after those barbecuers."

Taylor accused Kaszak—who had waged an unsuccessful campaign for 46th Ward alderman in 1987—of "trying to get her name in the papers. Nancy has done a terrific job selling [the Park District] a bill of goods. If she succeeds in removing us, then she can say she was the woman who saved the park. It's all political," Taylor added.

The Park District board unanimously voted to give the club ninety days to prove it was not violating any laws—or close down permanently. In the meantime, the club was ordered to hold its fire until it could prove it was complying with all state and federal laws.

Several members said the club was as good as dead. Lappe explained that while the membership voted to assess itself $50,000 to pay for any pre-dredging costs, "quite frankly it will be very difficult to get members to pay that assessment if they are unable to use the facility."

The Park District itself hadn't been much help during the whole episode, said Will Longnecker, another shooting club board member who said the club had earlier paid $32,000 for water and soil testing and even found a company to remove the lead. That effort failed when park officials refused to let the dredging boat dock in nearby Belmont Harbor but instead insisted the boat travel one to one and a half hours each way, every day, to reach the dredging site.

"Yup, the shooting's over," Robert Chen told a *Tribune* reporter as he was bulldozing one of the six wood and brick huts where the clay targets were launched.

"I don't believe we will ever open again. Our members may wish to spend monies on litigation that we would have spent on a cleanup," Lappe told the *Chicago Tribune* in February 1991.

Park Commissioner Joseph Phelps agreed the club would probably never reopen. "This is very unfortunate because they've been there longer than we have." (The citywide Park District was created in 1934.)

# FOUNDER OF PIONEER CHICAGO MUSEUM WASN'T ANYONE'S TYPICAL DESK-BOUND PAPER SHUFFLER

Ask someone to describe the "typical" museum curator and they're likely to conjure up images of a musty pedant in an ivory tower. That stereotype, of course, is inaccurate. Especially with regard to Robert Kennicott, a founder and the first curator of the Chicago Academy of Sciences (now the Peggy Notebaert Nature Museum at 2430 North Cannon Drive). He was never your typical museum director.

From the day he helped found the academy in 1857 until his death in Alaska six years later at age thirty-one, Kennicott probably spent a total of less than a year sitting behind a desk, doing the routine sorts of things we expect museum executives to do. Virtually all his adult life was spent in the wild, gathering one of the nineteenth century's most extensive collections of plant and animal specimens and filing on-the-spot reports credited with helping to persuade the United States to buy Alaska from the Russians.

Had he been an explorer, soldier or frontiersman rather than a scientist, Kennicott would undoubtedly have taken his rightful place in history with the likes of Kit Carson, Daniel Boone or Lewis and Clark. For in addition to being one of the first white men to visit parts of both the Russian and Canadian Arctic, Kennicott was just the kind of guy a hero-hungry country like ours usually can't resist enshrining in larger-than-life legends.

Lincoln Park Recreation and Cultural Center, shown here in 1975, moved into the Chicago Academy of Sciences, now the Peggy Notebaert Nature Museum on Cannon Drive. *Ravenswood/Lakeview Historical Association Collection.*

But in his case, the legends are true.

The day before his death of an apparent heart attack, he saved a Russian worker who was trying to desert the expedition in a stolen boat. The disenchanted voyageur reportedly took one of the exploring party's kayaks and headed up a stream filled with icebergs and rapids. A short distance from camp, the Russian's boat crashed into an iceberg and was sinking fast when Kennicott saw what was happening. Knowing the man wouldn't last more than a minute in the freezing stream, Kennicott commandeered another kayak and pulled the would-be deserter from the sinking boat just as it was about to go under. "Don't thank me, thank God," the furious and soaking wet Kennicott bellowed at the contrite Russian as he dragged him back to camp by the scruff of his neck.

The next day, Kennicott was found dead, some say because the strain of the daring rescue was too much for the frail explorer. For despite his career as an adventurer, Kennicott suffered notoriously poor health most of his life.

Born in New Orleans in 1835, he moved north with his family a few years later to a small farm northwest of Chicago. There at Kennicott's Grove, as

the property was named, he was home-schooled by his father, a physician, horticulturalist and editor of the *Prairie Farmer* magazine. Dr. Kennicott not only considered the boy too sickly to attend regular classes but also believed children could learn more from their parents and by observing nature firsthand than they could in any classroom. Nevertheless, the youth was evidently taught well enough that by his mid-teens, he was becoming a locally noted naturalist in his own right and was ready by the time he was eighteen to study for a winter with Jared Kirtland, a leading natural scientist in Cleveland, Ohio.

Through Kirtland, Kennicott became a protégé of Spencer Baird, assistant secretary of the Smithsonian Institution in Washington, D.C. By 1855, Kennicott had acquired enough of a reputation to be asked by the Illinois Central Railroad to make a survey of the natural resources along the right of way from Chicago to Cairo, Illinois. During that trip, he also carried on his own private project: collecting snakes, small mammals and birds for shipment to Baird at the Smithsonian's research laboratory.

Hoping to find a living specimen of a water moccasin as he passed through southern Illinois, Kennicott offered a five-dollar reward to the first person who brought one in. Within a few days, he had his snake and a local farmer had his five dollars. Unfortunately, another man with a snake, not knowing that the reward had already been collected, took a swing at Kennicott. Thinking fast, the young scientist asked to have a closer look at the snake. Convinced he would get the five dollars after all, the man carefully handed the water moccasin to Kennicott. Now armed with the poisonous snake, Kennicott quickly routed his would-be assailant.

Still planning to follow in his father's footsteps, Kennicott enrolled in medical school the next winter, but his poor health again kept him from attending classes. Moving from the family farm to Chicago, he soon joined several other scientists in setting up the Chicago Academy of Natural Sciences in rented quarters on Dearborn Street and then took a research job at Northwestern University.

In 1858, however, he was well enough to make his first Arctic expedition as part of a team surveying the natural resources in Canada's Hudson Bay area. While there, he also became the only "doctor" many of the local Indians would ever see. One of Kennicott's favorite remedies, incidentally, was a morphine-based compound he used to put the ailing natives to sleep long enough to recover on their own. "Usually they were suffering from something minor," Kennicott recalled in one of his letters. "They would have recovered in any case, but after taking this remedy, they would believe anything I said."

Finally getting the news that the long-expected Civil War had erupted, Kennicott returned to Chicago in 1862, planning on joining the army. But he eventually bowed to relatives' arguments that a man in his "delicate health" wouldn't last more than a few weeks on the front lines. Kennicott instead went back to Washington, where he helped catalogue the specimens he had collected in Canada for both the Smithsonian and the Chicago Academy.

In 1864, he was back in Chicago as the first full-time director of the Chicago Academy, and a few months later, he was off to Alaska to join an expedition sponsored by the Western Union. His primary job was to help survey the area for the telegraph company, which was planning to string wire across what was then known as "Russian America" to the Bering Strait and link up with a team laying a line across Siberia. But as always, Kennicott had his own studies as well.

This time, however, Kennicott didn't come back. In the summer of 1866, Chicago Academy trustees learned he had died near Nulato, Alaska. Little did they know that the information in his reports home would soon help convince U.S. secretary of state William Seward that the czar's offer to sell "that Icebox" for $7.2 million wasn't such a bad bargain after all.

# Goddess Worship, Witchcraft, "Flirty Fishing," Vegetarian Feasts: Pick Your Path to Nirvana

Charles Renslow and Frederic D'Arechaga had a lot in common, yet for about a decade, they waged their own quiet religious war against each other. Renslow, owner of a string of North Side gay bars and bathhouses in the 1970s and '80s, was also the Pristine Egyptian Orthodox Church's "arkon of North and South America," the "spiritual pharaoh" of a handful of followers in a storefront temple at 2445 North Halsted Street. According to a one-time parishioner, the Sunday afternoon service was "kind of Catholic and MGM Egypt."

D'Arechaga was the self-styled "Pontifex Maximus" of the Sabaean Order, which worshiped in the back of the El Sabarum ("of many gods") occult shop dispensing herbs, incense, goat hooves, robes, elixirs to absorb evil spells and even ceremonial daggers. The Temple of the Moon, where the toga-clad Sabaean faithful worshiped, was decked out in purple gauze, cushions, incense braziers and Greek pillars, with pigeons in the background. Services usually ended with food brought by members of the congregation. "We don't eat our gods. We eat *with* our gods," a former parishioner recalled hearing during one of the feasts. Describing himself as a "hereditary witch," D'Arechaga said he was continuing a family tradition passed on through his mother.

Chuck Renslow, "Supreme Arkon" of the Pristine Egyptian Orthodox Church, conducts services honoring the ancient gods in a storefront temple at 2445 North Halsted Street in the early 1970s.

During a 1970 interview with *Chicago Tribune* reporter Mary Daniels, D'Arechaga described his faith as the victim of a major misunderstanding. The "Old Religion" he represented, D'Arechaga explained, antedates today's more established faiths like Christianity, Judaism and Islam, which are merely offshoots of earlier religions like his.

Sabaeanism was based on Babylonian, Sumerian and African myths and theologies, explained the Pontifex Maximus, who borrowed the title from the pope and Roman emperors. And "we're not Satanists," D'Arechaga told a Lerner Newspapers reporter a few years later, around the time *The Exorcist* had just hit theaters. "That hurt our image," he said, complaining that people would cross themselves as they passed the store or move across the street to avoid getting too close to the building. Some, he added, would even throw dead cats at the temple.

Sometime in the mid-1970s, the embattled high priest converted to Santeria (a form of Voodoo), changed his name to Odun and moved to New Orleans, where he and those who followed him to the Crescent City began

worshipping a new god, Obatala. According to Youriban beliefs, that's the god who created a flawed human race because he was drunk on palm wine, Odun explained.

Their following began unraveling after Odun suffered a stroke and died in his sleep in January 2011. By all accounts, modern Sabaeanism apparently died with Frederic D'Arechaga.

Things went a little easier for rival cult leader Charles Renslow, who considered himself inheritor of the "original" Egyptian religion built around the monotheistic beliefs of Pharaoh Amehotep IV in 1375 BC. According to Renslow and "Rev." Milton Neruda, Amehotep (or Ikhnaton) believed in one god who had many names. "Like a diamond with many facets," Renslow explained.

Renslow and Neruda eventually split over how their church should deal with Christianity. Neruda wanted the church to be more vocal in its criticism. They eventually parted ways, with Neruda forming a rival group, the Congregation of Aton. Neither group survived.

Not that anyone would have noticed back in those days when Lincoln Park—like much of the North Side—was a veritable hotbed for off-brand sects of all sorts.

Before moving to suburban Evanston, the Hare Krishnas had their Midwest headquarters in an apartment at 818 West Altgeld, where they threw vegetarian "love feasts" every Sunday afternoon. Uniformed members of the Process Church of the Final Judgment, reportedly a Scientology splinter group, occupied a former mansion on the 600 block of West Deming Place. Not that far away, the Foundation Church of the Millennium, which broke away from the Processians, had its Midwest headquarters and coffeehouse at 1529 North Wells but dropped from sight sometime in the mid-1970s.

During the 1970s, there were at least two witches' covens, persistent reports of a Satanist cell, "reformed" Druids who communed with their gods in an apartment at the west end of Lincoln Park and an occasional "Moonie" or two selling flowers from dawn until midnight to help support the Unification Church's operations.

Then there was the Holy Order of MANS (HOOM), otherwise known as the Christ the Savior Brotherhood (CSB), a "Christian commune" on the 2300 block of North Oakley. The "priests," "brothers" and "sisters" led a semi-monastic life. CSB plucked its beliefs and practices from a variety of sources ranging from Pauline Catholicism and Spiritualism to Masonry and Rosicrucianism. Although the group all but dissolved when a number

of CSB adherents turned to Eastern Orthodoxy, a handful of holdouts claim to maintain the original HOOM teachings and practices on several Internet sites.

Also roaming the neighborhood peddling pamphlets during the 1970s were the Children of God (later renamed the Family of Love). The "church," headquartered for a time in a town house at 1312 North Astor, came under fire for brainwashing and allegedly sexually abusing some of the younger members. The cult also raised eyebrows for trying to recruit converts through "flirty fishing." It's claimed that sect members had sex with 223,989 potential converts using this controversial form of evangelical outreach. The Family of Love dissolved when its founder, "King" David Berg, a former Baptist minister who called himself "the Last End-Time Prophet," fled to England in the face of a federal tax investigation.

On hand to serve the ceremonial needs of many of these congregations was the Equinox occult store at 3011 North Halsted, which specialized in candles, incense, ritual wands, custom-made vestments and even made-to-order altars.

# Elks Founder's Fight for Reinstatement, Recognition Took Decades after His Death

In March 1980, the Elks National Memorial headquarters at 2750 North Lakeview marked the 100<sup>th</sup> anniversary of the death of Charles Vivian, an English actor who founded a one-million-member fraternal organization almost by accident. But although he is now remembered in the world-renowned North Side landmark that looks so much like a replica of the Jefferson Memorial in Washington, D.C., Vivian died in the midst of a heated controversy over who really founded the Benevolent and Protective Order of Elks. It was only after a twenty-five-year battle ending with an official inquiry in 1897 that Vivian was finally credited with being the fraternal order's founder. The dispute started almost as soon as the group elected Vivian as its first leader at the Elks' first official meeting in New York City.

The twenty-one-year-old son of an English clergyman was a music hall comic who had been in the United States only a few months when he and a handful of other show folk began meeting on Sundays in a boardinghouse as a way of escaping the tedium of New York's blue laws, which in those days kept all theaters and taverns closed on the Sabbath. A loose organization was created mainly to keep Vivian and his friends supplied with enough food and drink for their soirées. The friends soon started calling themselves the Jolly Corks, supposedly because of a cork trick Vivian had learned in the London pubs.

Back then, however, an actor's life was even more insecure than it is today. Shortly after a member of the Jolly Corks died over the 1867 Christmas

Dedicated in 1926, the Elks Memorial Building at Diversey and Sheridan Road is a tribute to the more than one thousand members of that fraternal organization who died in America's wars. *Photo by Patrick Butler.*

holidays, leaving nothing to help support his widow and children, Vivian suggested creating a benevolent society to aid members and their families in times of need.

The Jolly Corks' thirty members set up committees to draft bylaws and come up with a new, more serious name for the group. Although Vivian himself wanted to call the new organization the Buffaloes, after England's Royal Antediluvian Order of Buffaloes, others opted for starting fresh with a completely new name. Legend has it some committee members got the idea of calling themselves the Elks after seeing an impressive elk's head in Barnum's Museum on Broadway in New York.

At any rate, when the Jolly Corks met on Sunday, February 16, 1868, the Jolly Corks officially became the Benevolent and Protective Order of Elks. Vivian was promptly elected the group's "Right Honorable Primo," a title that eventually went the way of the early Elks' ceremonial robes and passwords.

Within a decade, Elks lodges had been chartered in Philadelphia, San Francisco and Chicago, but dissention in the ranks developed

almost immediately. A faction led by George McDonald wanted to restrict membership to theater people, while Vivian wanted to open the group to anyone who wanted to join. The McDonald clique reportedly waited until Vivian was safely out of town and then expelled the Right Honorable Primo and some of his closest friends, arguing that Vivian was dishonestly claiming credit as the group's founder. Although the national Elks later overturned the illegal expulsion, the dispute over who really founded the Elks was still raging even after Vivian and his wife left town to organize a theater troupe that tried to open with *Oliver Twist* in the Colorado gold fields.

Soon forced to pack it in for lack of business, Vivian took ill and died at age thirty-four in March 1880. Nine years later, the Elks moved his body to Mount Hope Cemetery in Boston. A short time later, Vivian was officially credited with founding the order, and his widow began receiving a pension from the Elks that continued until her death in 1931.

Vivian also posthumously won his battle to keep the Elks open to everyone, not just performers. By 1921, the Elks had grown large enough to build their own national headquarters and a memorial to the more than one thousand members killed in World War I. Chicago was selected for its central location. A total of $2.3 million was raised through lodge assessments, and the order bought a piece of land facing Lincoln Park. The building was officially dedicated on July 14, 1926, amid daylong festivities. Twenty years later, the memorial was rededicated to Elks who died in World War II.

Over the years, the Elks have not only continued their tradition of aiding members in distress but have also raised funds for handicapped children, college scholarships, youth leadership projects and recreational programs for patients in veterans' hospitals. The order also started Flag Day observances on June 14, 1907, a tradition later made into a national holiday by the federal government.

The first two U.S field hospitals set up in France during World War I, incidentally, were financed and equipped by the Elks Grand Lodge. And the order is credited with raising a large part of the funds used by the Salvation Army during that war. After the Armistice, the Elks set up a veterans' hospital, a seven-hundred-bed facility in Boston. And the Grand Lodge organized a GI loan program to help returning doughboys pay their expenses while waiting for their government benefits to be approved. During the next war, the Elks became the only civilian organization authorized to recruit construction specialists for the army and navy and met their quota three months ahead of schedule.

The Jolly Corks have come a long way since their first meeting in that New York boardinghouse. And it's not surprising that their national headquarters is in Chicago. Vivian himself was no stranger there. During his years as a traveling entertainer, he had performed here often enough that a local newspaper ran the following eulogy at the time of his death: "No man in the profession had so wide a circle of admiring and warmly-attached friends among the younger men of this city. With Vivian's last breath went out a life that should have been illustrious."

# U.S.-Born Irish President, Controversial Romanian Queen Had Very Different Visits on Webster Avenue

Mrs. Eleanor Roosevelt, who dedicated the Lathrop Homes, wasn't the only notable to visit the Lincoln Park area. In 1919, Eamon deValera, the American-born future president of Ireland, spoke at St. Vincent's Church, 1010 West Webster, during a fundraising tour. While at DePaul University, he met with George Cardinal Mundelein and received an honorary degree from Father Francis McCabe, the school's president. University officials said at the time that deValera was the first international figure to receive an honorary degree from an American college.

But if "Dev's" visit to Chicago was nothing short of a march of triumph, the 1926 visit of Romania's Queen Marie was an almost unmitigated disaster even though authorities thought they had everything perfectly planned, starting with the cavalry escort from Union Station to city hall, the visit to the lakefront at Irving Park Road and the stop at the Lincoln statue on North Avenue, where the monarch, with the help of 500 Boy Scouts, laid a wreath at the Great Emancipator's statue. Then it was on to a luncheon at Edith Rockefeller McCormick's 1000 North Lake Shore Drive mansion, followed by Mass at St. Mary's Orthodox Church at 1345 West Webster and a visit to Knickerbocker School at 2301 North Clifton, where many of the 1,400 pupils were more Romanian than the half-German, half-Russian Queen Marie herself.

Now a private residence, the former St. Mary Romanian Orthodox Church, 1345 West Webster, reportedly still has the parish's small cemetery on the property. *Photo by Patrick Butler.*

Things started going downhill when Marie, the granddaughter of England's Queen Victoria, was halfway through her four-day visit here. First her son, Prince Nicolae, refused to accompany the royal party to an Eighth Street Theater musical, even though the queen sent a cop to fetch him. Then there were the uneasy moments when Marie's daughter, Princess Ileana, disappeared for an unscheduled swim at the Racquet Club at 1361 North Dearborn Street. Later there was uproar when the queen lit a cigarette during a banquet at the Drake Hotel. Then Prince Nicolae got yelled at by a group of outraged elders as he started to enter a Romanian Jewish synagogue without a hat.

The chaos continued when the police escorting the royal motorcade to the Women's Athletic Club didn't know where it was located. Marie ordered the procession to stop in front of a medieval French-style complex on Rush Street north of Chicago Avenue. "Surely this must be the place," she said. It turned out to be Quigley Seminary.

The police officer in charge probably summed up the situation best: "What do we do now? We're all balled up."

# 1969 Murders of Activist Pastor and His Wife Remain Unsolved after All These Years

In October 2013, the Young Lords Organization held a memorial service honoring Reverend Bruce Johnson and his wife, Eugenia. The pair had been found brutally murdered on September 30, 1969, in the parsonage of the Armitage Avenue Methodist Church at 834 West Armitage. Pastor Johnson had fourteen stab wounds in his stomach and chest, and his wife had been stabbed nineteen times, with her skull crushed. Their four-year-old son, Brian, stood at the front steps of the apartment when some friends arrived to find out why Johnson hadn't shown up for a racquetball appointment. "It was a terrible scene," Reverend Martin Deppe, a fellow Methodist minister and a friend of the Johnsons, told the DePaul University newspaper after the ceremony.

The case has never been solved, even though there were plenty of people out there who for various reasons were no fans of the victims. After all, neither the Johnsons nor the church itself were strangers to controversy. Both had been under fire from several community groups, as well as the more conservative Cuban parishioners. Neither group was happy with Reverend Johnson for letting the Young Lords use the church as a base of operations for everything from a soup kitchen to numerous anti-gentrification rallies led by Jose Cha Cha Jimenez, who learned about the murders while in solitary confinement in Cook County Jail.

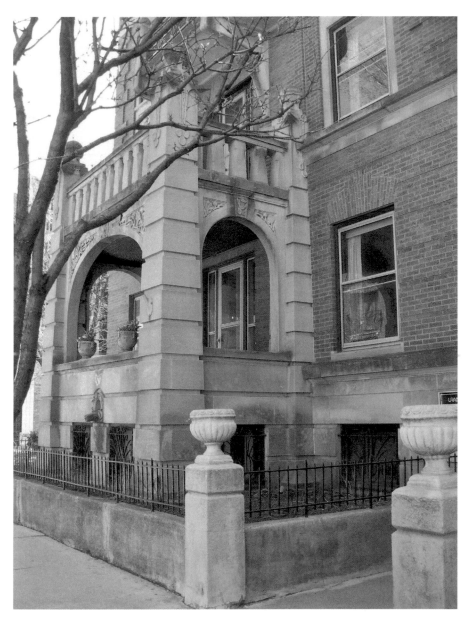

For more than fifty years, the Urantia Foundation has been located at 533 West Diversey. It's a philosophy built around the *Urantia Book*, which believers say was dictated to a Chicago psychiatrist. *Photo by Patrick Butler.*

"The warden himself actually had me come to his office, asked if I wanted a beer, then put on the TV. And that's when I saw it on the news," Jimenez told *DePaulia* reporter Tom Fewkes. About an hour later, after questioning by homicide detectives, Jimenez was bonded out by Methodist bishop Thomas Pryor himself so the Young Lords leader could give one of the eulogies at the Johnsons' funeral.

Certainly there were plenty of people who would have liked to see both the Johnsons and the Young Lords put out of business, starting with 43rd Ward alderman George Barr McCutcheon. He had one of his news conferences stormed by the Young Lords, who reminded reporters about McCutcheon's 1968 arrest in company with a known prostitute in a parked car under the el tracks near North and Halsted. (For the record, McCutcheon, who was also a teacher at the tony Francis Parker private school, told officers he was just doing "research" into at-risk youth in his ward.)

In a letter to Bishop Pryor, Carolyn Barnett of the Mid-North Association had asked if church authorities were aware of the "takeover" of Armitage church with "arms on the premises and meetings to incite violence and revolution."

McCutcheon sent a letter to the Methodist Church's Northern Illinois Council sharply criticizing the Armitage congregation's association with "violent groups" and allowing "illegal painting of walls" promoting groups like Strike Against the War and a large painting of Ernesto "Che" Guevara, as well as other "paintings of people with guns," and the use of the church building to "house out of town revolutionaries." The alderman went on to accuse Reverend James Reed, pastor of the Church of the Holy Covenant at 925 West Diversey, of being "increasingly involved with violent dissidents" who met at Reed's house "to plan the disruption of the Lincoln Park Conservation Council."

In a memorably crafted reply issued "To Whom It May Concern," Carl Mettling, superintendent of the denomination's Chicago Northern District, said the church "supports the work of its pastors and local congregations in their efforts to engage the cause of Christ in the community," including efforts "to be present to the poor and powerless in their struggles for economic justice and social equality.

"It is our conviction that this ministry to the Young Lords Youth Organization, endorsed by the proper local church, is being engaged in creatively and democratically," Mettling said. "This is not to say that every word and deed" of the clergy and parishioners necessarily has the approval of the church but only "that the [Armitage Avenue] Church is seeking to perform a ministry of reconciliation in a deeply needy area.

"The Church has an unavoidable responsibility to the youth of Chicago on which it dare not turn its back," Mettling trumpeted.

Other enemies, Jimenez suggested, included the local "Italian Mafia," whom "Cha Cha" accused of running an "extortion numbers racket" out of a real estate office the Young Lords picketed after a local restaurant owner was allegedly threatened by a bill collector with a submachine gun for not paying his rent on time.

By then, most of the Armitage church's Cuban parishioners had already quit over the Young Lords' praise for Che Guevara, Deppe recalled.

But "I don't know [who was behind the murders]. I do not want to speculate. It's an unknown to this day," Deppe told Fewkes.

# "Outsider" Artist Henry Darger's Talent Known to Only a Few During His Lifetime

After Henry Darger's death in 1973, his former landlords at 851 West Webster, Nathan and Kyoko Lerner, found a 15,145-page, single-space, typed manuscript bound in fifteen volumes titled "The Story of the Vivian Girl in What Is Known as the Realms of the Unreal, of the Glandeco-Angelinian War Storm, Caused by the Child Slave Rebellion." The several hundred accompanying illustrations show otherworldly beasts and near-naked young hermaphrodite children being tortured and killed.

Darger was an enigma from the very start. Born in 1892 in a house at 350 West 24th Street, he lived with his father until Henry Sr. became so ill and impoverished that he was taken in at St. Augustine Home at Fullerton and Sheffield, run by the Little Sisters of the Poor. After a few years at the Mission of Our Lady of Mercy on the Near West Side, the younger Darger was sent to the Illinois Asylum for Feeble Minded Children in downstate Lincoln, where one doctor wrote in his report that "Little Henry's heart is not in the right place" because of habitual "self abuse" (masturbation), which many doctors of the day believed led to insanity and blindness.

Tired of being bullied by other children and subjected to the severe punishments of that era, Darger made several escape attempts, finally succeeding in 1908. He returned to Chicago, later ending up in the Cook

County Insane Asylum, better known as Dunning. "It was a poorhouse, a hospital, a mental institution and a hellhole," according to one Darger biographer, Jim Elledge.

With the help of his godmother, Darger eventually got a job at St. Joseph's Hospital, where he worked until his retirement in 1963 except for a hitch in the army during World War I.

A devout Catholic, Darger often attended five Masses a day at nearby St. Vincent DePaul Church on Webster Avenue. Darger and one of his few friends, William Schloeder, shared a concern for mistreated kids and talked about starting a "Children's Protective Society" that would help put abused and neglected children up for adoption by good families. Nothing ever came of the plan. Schloeder left town in the early 1930s, but the two stayed in touch until Schloeder died in 1959. Elledge hints the two may have been lovers.

Henry Darger Jr. died at eighty, ironically in the same St. Augustine Home where his father had passed away sixty-eight years earlier. The last entry in his diary, dated January 1, 1971, said a lot about the man: "I had a very poor Christmas. Never had a good Christmas all my life. Nor a good New Year. And now I am very bitter but fortunately not revengeful, though I feel [that] should be how I am."

Darger was buried in the Old People of the Little Sisters of the Poor Plot reserved for the indigent aged in All Saints Cemetery in suburban Des Plaines. The grave marker reads "Artist" and "Protector of Children."

Some critics dubbed his magnum opus, apparently done over a sixty-year period, a superb example of "outsider art." Some of his sketches are in the Chicago Art Institute, New York's Museum of Modern Art and the American Folk Art Museum, which opened a Henry Darger Study Center in 2001. The work of this lifelong janitor once diagnosed as "retarded" brings as much as $80,000 per piece and is now considered among the highest-priced art of any self-taught artist.

There are even spinoffs of Darger's work, like John Asbury's 1999 book-length poem, *Girls on the Run*; a multi-player online computer game, *SiSSYFiGHT 2000*; Jesse Kellerman's 2000 novel, *The Genius*, drawn partly from Darger's life story; and choreographer Pat Graney's 2004 multimedia piece using some of Darger's drawings. There's even *Darger and the Detective*, a play done by Chicago's Steppenwolf Theater Company for BBC Radio.

Who'd have imagined?

# For Many Hoops Fans, Ray Meyer Wasn't Just Another Basketball Coach—He Was *The* Coach

When Ray Meyer became DePaul University's head coach in 1942, he turned down a three-year contract. He insisted instead on a one-year pact at $2,500. "I didn't know if I'd like the job," he explained in his memoirs, *Coach*, ghostwritten by *Chicago Sun-Times* sportswriter Ray Sons. As it turned out, he liked it enough to stay for the next forty-three years, turning down offers from bigger, better-known colleges and even the pros as he took his Blue Demons to the NCAA Final Four twice, in 1949 and 1975.

Born one of ten children to a Chicago candy wholesaler, "the Coach" had originally planned to become a priest but decided basketball was his true calling after starring on the Quigley Preparatory Seminary team, which won the Catholic high school national title in 1932. He got a Notre Dame scholarship, became co-captain of the basketball squad in his junior and senior years and after graduation served as assistant coach for the Fighting Irish before coming to DePaul as head coach in 1942.

During Meyer's first season, he recalled in his autobiography, "I saw my future" when he spotted a gangly six-foot, ten-inch, 245-pound sophomore with thick glasses who had never played competitive high school basketball. Like Meyer, he had also studied for the priesthood at Quigley but left to

pursue a seemingly unlikely basketball career. George Mikan, he concluded, "had raw material with little talent."

Rising to the challenge, he drilled the future "Mr. Basketball" who would become college player of the year—twice. He would eventually be voted the greatest hoops player of the first half of the twentieth century in an Associated Press sportswriters' poll. The transformation didn't come easily. Meyer spent hours running Mikan through the game's fundamentals. "I was a slave driver and he was a willing slave," he said.

During the 1950s, Meyer enhanced his growing national reputation by coaching college all-star teams that toured the country playing the Harlem Globetrotters. Meyer's star rose even higher in the late 1970s when DePaul's roster included future stars Mark Aguirre, Terry Cummings and Dave Corzine.

While it was nothing new for Ray Meyer to coach a team headed by his son, Joey, who would later succeed him as the Blue Demons coach, it was a new experience for the Coach to be coaching against his oldest son, Tom. During the opening game of the 1981–82 season, Tommy Meyer was coaching the University of Illinois–Chicago team. Dad beat his son 78–53 in what may have been the first intercollegiate game with a father and son coaching opposing teams.

There were times, however, when basketball life at DePaul was anything but a slam-dunk. In 1971, during DePaul's worst season—an 8-17 win-loss record—with an average of only 1,200 fans turning out and the athletic department suffering a $200,000 loss, the powers that be were even wondering whether it was time to discontinue basketball altogether. Not surprisingly, Ray Meyer's arguments not only saved the program but also got the school to allocate even more money for the coming season to give Meyer his first player recruiting budget and funds to hire his first full-time assistant, who turned out to be his son, Joey Meyer. It proved a good choice. Within a few years, DePaul was getting the cream of the crop from Chicago suburbs as well as the public school league.

Ray Meyer and the Blue Demons had become such hot ticket items that in 1980, the team left Alumni Hall for the seventeen-thousand-seat Horizon in suburban Rosemont.

When Meyer retired in 1984, he left an almost unheard of 724-354 win-loss career record. Over the years, Ray Meyer was there for 1,467 games over a fifty-five-year period as a coach or basketball broadcaster. He was inducted into the Naismith Basketball Hall of Fame in 1979. At the end of his coaching career, Ray Meyer's record placed him fifth in career victories among college coaches.

This 1907 building at Webster and Kenmore was built along with the Lyceum and the Theater on the 2200 block of North Sheffield Avenue for a then-hefty $500,000. *Photo by Patrick Butler.*

Asked why he never grabbed any of the lucrative offers that came over the years, including one from his alma mater, Notre Dame, Meyer told more than one reporter, "I hate change." But change was something he and every other coach had to adapt to in an entire society that was changing almost beyond recognition.

"Years ago you could rant and shout and yell at 'em and scream at 'em [the players]. If you do that today, they say 'that guy's nuts.' So you reason more. You explain things to them," Meyer told a *Chicago Tribune* reporter.

As expected, Meyer's son Joey took over as head coach upon Ray Meyer's retirement, while Ray stayed on at DePaul as a special assistant to the school's president for community relations and fundraising. He stayed on for another thirteen years until son Joey Meyer was fired following a disastrous 3-23 season.

"I live with my family and my family is kind of bitter about the whole thing," Ray Meyer told the Associated Press after resigning in protest over the treatment of his son. But after all, he added, "I was only an employee," and the university would survive nicely without him.

Other sources said Coach Meyer was almost relieved to see Joey ousted as coach and that what he was really mad about was the timing, in late April, when most coaching vacancies have been filled. By then, Ray Meyer suspected his son "places too much importance on the game. Sometimes I think he should just walk away," Meyer told the *Los Angeles Times*. "He doesn't eat. He stays up all night watching tape. I worry."

In 1999, when DePaul inducted the entire 1978–79 Blue Demons team into its Hall of Fame for making it to the Final Four, Meyer refused to attend. But by the end of the year, when the school dedicated its new Ray Meyer Fitness and Recreation Center, the Coach and DePaul had buried the hatchet. This time, Ray Meyer did show up.

In the end, the Coach and his school apparently couldn't stay apart forever.

# Widowed Chilean First Lady Blamed CIA Coup for Death of Her Husband, "Reign of Terror"

The widow of Chilean president Salvador Allende told a gymnasium filled with an estimated two thousand Chicagoans that her controversial husband was overthrown and murdered because he was making life too difficult for the rich and powerful both in Chile and in the United States.

Addressing a December 16, 1973 rally at DePaul University's Alumni Hall, 1011 West Belden Avenue, Hortensia Allende blamed the September 11 coup three months earlier on collusion between Chilean right-wingers, American-owned corporations and at least several U.S. government agencies.

Although the official account said President Allende shot himself rather than surrender to the plotters, Mrs. Allende grew increasingly skeptical of that story. She conceded that while there was some economic dislocation in Chile during her husband's attempted transition to socialism, it was groups like the U.S. Central Intelligence Agency and International Telegraph and Telephone that deliberately aggravated the problems leading to the military junta's takeover. As soon as the junta moved in, Madame Allende said, wages were cut and prices were raised. Inflation, she added, went from 200 percent during the last days of her husband's presidency to 1,800 percent three months later.

Even scarier, Mrs. Allende added, was the junta's reign of terror aimed at political dissidents, labor leaders, educators, journalists and students. During

Now part of the DePaul University campus, these Queen Anne–style row houses were built between 1884 and 1889 by the McCormick Theological Seminary as an investment. *Photo by Patrick Butler.*

the first weeks of the army takeover, she said, some of the top university deans in the country were fired and replaced with what Mrs. Allende described as semi-literate army officers. Scores of dissenters were sent off to concentration camps, and a number were killed almost immediately, she continued. Mrs. Allende added that those who left the country and couldn't be arrested by the junta had their Chilean citizenship revoked.

Speaking in Spanish through a translator and frequently choking back tears, she called on ordinary Americans to start pressuring Washington to withhold aid to the new regime until the political prisoners in Chile were freed and some semblance of freedom was restored to the Chilean people.

Backing up her plea for help were North Side writer and radio personality Studs Terkel, DePaul vice-president Reverend John Richardson and Patrick Gorman, international secretary of the Amalgamated Meatcutters' Union, then at 2800 North Sheridan Road.

"Your very presence here is helping save lives in Chile," Terkel told the overflow audience, explaining that a few more rallies this size may be needed

to force U.S. politicians to take a second look at the aid they had been giving the junta.

Comparing resistance to Chile's new military government with Ireland's struggle for freedom fifty years earlier, Gorman said it's perfectly natural that he, an Irish-American, should have an intense interest in what happens in Chile. After all, the George Washington of Chile, Bernardo O'Higgins, was the son of an Irish father and a Latin American mother. "I doubt if there's been any fight for national independence or human dignity in recent centuries that didn't have at least one Irishman or Irishwoman involved," he said.

Praising Allende as a "beautiful dreamer of a better life for the Chilean people," Gorman predicted that if the American public kept the pressure on both Washington and Santiago, "the sun will rise again in Chile."

Still another speaker, Frank Teruggi, father of a suburban Des Plaines student who was killed by the junta shortly after the takeover, said pressure on the U.S. government was undoubtedly one of the reasons inquiries into the

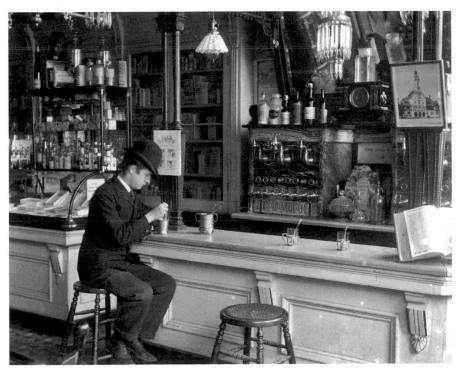

Vogelsang's Pharmacy near Lincoln and Fullerton around 1895, back in the days when any self-respecting drugstore had a soda fountain. *Ravenswood/Lake View Historical Association Collection.*

circumstances of his son's death were now being conducted "at the highest diplomatic levels." Teruggi suggested keeping the same kind of pressure to help force the junta to change some of its policies.

It took a while.

General Augusto Pinochet, ringleader of the 1973 coup that overthrew the duly elected Allende government, remained in power until 1988, when he was removed by a recall vote made possible after Pinochet loosened his grip and allowed creation of rival parties for appearances' sake.

Forced into a fifteen-year exile, Mrs. Allende and two of her three daughters lived in Mexico and made occasional American speaking tours until 1983, when she was refused a U.S. visa "because her entry to make various public appearances and speeches had been determined to be prejudicial to U.S. interests," a State Department spokesman explained. Mrs. Allende had been invited to the United States by the Catholic archdiocese of San Francisco. She died in 2009 at age ninety-four, outliving Pinochet, who had died three years earlier before he could be brought to trial for assorted human rights violations.

# CHILDREN'S HOSPITAL WRAPS UP 131 YEARS HERE TO BEGIN WHOLE NEW CHAPTER OF PUBLIC SERVICE

At about 6:00 a.m. on June 9, 2012, a ventilator containing five-year-old Emiliano Vasquez and several teddy bears were taken by ambulance from Lincoln Park's Children's Memorial Hospital (CMH) to the brand-new twenty-three-story, $855 million Lurie Children's Hospital at 225 East Chicago Avenue.

Over the next fourteen hours or so, 126 of Chicago's tiniest, sickest and bravest patients made the three-and-a-half-mile trip under police and fire department escort. About 30 police traffic aides were posted along the route to make certain everything moved smoothly. Also on hand were platoons of paramedics, nurses and parents. Hospital officials said up to twenty-five ambulances had been lined up for the move.

Contingency plans called for keeping Fullerton Avenue to Lake Shore Drive to Chicago Avenue shut down for up to forty-eight hours if necessary. The $30 million move—more than three years in the making—was reportedly the biggest hospital relocation anyone could remember.

Later that evening, hospital staff started going from floor to floor turning out lights, ending the city's first children's hospital's 131 years in Lincoln Park, a saga that began with an eight-bed frame cottage at Halsted and Belden. Originally named the Maurice Porter Memorial Hospital, CMH was started by wealthy widow Julia Porter in memory of her 13-year-old son who died of acute rheumatism. Bereavement was nothing new to Mrs.

Porter, who had lost her father, husband and son in the space of 6 years. To nobody's surprise, she always wore black.

The 1880s weren't a good time to get sick, especially if you were a child, said Dr. Stanford Shulman, head of infectious diseases at Lurie Children's Hospital. "Back then, children under five accounted for most of Chicago's deaths, often succumbing to infections related to tainted milk, food and water. Child labor was also a serious problem," said the self-described history buff and author of a pictorial history of CMH published by Arcadia Publishing.

In the late nineteenth century, malnutrition and failure to thrive were serious problems, while the 1930s saw numerous cases of tuberculosis and polio. Back then, heliotherapy—exposure to sun and fresh air—was a popular TB treatment. But children in those days were more likely to be treated with home remedies like gin for scarlet fever or "Goose Grease" for whooping cough than taken to a doctor.

At Children's Memorial back in the early days, treatment was free, Shulman said.

A few years after opening her small hospital, Mrs. Porter bought several more lots at Orchard and Fullerton to build a twenty-bed, three-story hospital building. In 1896, a new wing was added that included the first isolation ward, upping the bed count to fifty. A dozen years later, a fifteen-crib unit was added, along with a milk laboratory and a classroom for the mothers. In the 1960s, a new street—Children's Plaza—was added to give ambulances easier access to the emergency room. Growth continued until 2002, when the hospital's research center was completed. At about the same time, CMH was clearly outgrowing the old neighborhood, and serious talk began about moving the old hospital elsewhere.

In 2006, Children's announced plans to move near the Northwestern Memorial Hospital complex site in Streeterville with the help of a $100 million mega donation from another wealthy widow, Ann Lurie. Like Mrs. Porter, she had also made a full-time job of giving away money.

# Even "Uncle Win" Never Expected to See the Old Town School Someday Get This Big

What is now the country's largest music school of its kind started in the spring of 1957 in a second-floor studio in the Old Immigrant Bank Building at 333 West North Avenue—mostly because WLS-Radio *National Barn Dance* personality and children's entertainer "Uncle Win" Stracke wondered why there was no school for aspiring folk singers.

After all, those were the heydays of groups like the Weavers and the Kingston Trio, as well as places like the Gate of Horn, an early folk nightclub at Chicago and Dearborn where Stracke had a gig despite being blacklisted during Senator Joseph McCarthy's witch hunts for his support of labor unions and other progressive causes. (As the saying went, Stracke "was not, nor was he then, a member of the Communist Party.") Stracke was apparently busy enough working as a suit salesman, suburban Lake Bluff police officer, gas station attendant, coal miner, oil field worker, fruit picker and tramp steamer crewman before his interest turned to folk music. His school's "faculty" included then-unknown folk musician Frank Hamilton and Oak Park housewife Dawn Greening, who served as the school's registrar and general factotum. At a time when most music instruction was one-to-one, Hamilton developed a technique for group teaching that allowed him to be both a mentor and an active

performer, Stracke explained in his promotional pamphlet on the Old Town School's history, *Biography of a Hunch.*

As the nationwide popularity of folk music continued to soar with the political messages of artists like Bob Dylan and Joan Baez, so did enrollment at the Old Town School, where more than 150 students were taking weekly guitar, banjo and voice classes. Folk dancing and group singalongs became regular features, as did concerts by national stars like Pete Seeger, Jimmy Driftwood and even spirituals virtuoso Mahalia Jackson.

Win Stracke continued writing and performing songs of his own like "The Ballad of the 43rd Ward," in which he talks about how the news of Prohibition "never got through to Willow and Howe" in the heart of the seemingly "unreformable 43rd."

Over the years, the entertainment repertoire expanded to include Scottish singer Jean Redpath and "world music" by entertainers from everywhere from Tibet to Quebec. Future high-profile performers like Bonnie Koloc, John Prine, Bob Gibson and Steve Goodman were all students at the school, which in 1968 moved to a thirteen-thousand-square-foot building it still owns at 909 West Armitage.

Twenty years later, the Old Town School took over the former Hild Library building at 4544 North Lincoln Avenue. "When the school moved here, there was a lot of consternation over whether we could fill this building," executive director Bau Graves told the *Chicago Tribune*'s Greg Kot. "In a couple of years we had classes running in prime time in every room. There's been a lot more demand than we can accommodate. We end up saying 'no' a lot."

So in January 2012, the Old Town School built a new building with sixteen music classrooms, three dance studios and an auditorium just across the street from the old Hild building. The school was teaching 6,000 students a week (including 2,700 children) and had plans to increase the number of classes offered from seven hundred to nine hundred and expected to add nearly 100 part-time teachers to the payroll.

Even many who had been there from the start were pleasantly surprised. At the school's fiftieth anniversary gala, Frank Hamilton, as an honored guest at a packed concert at the Auditorium Theater in the Loop, recalled that long-ago opening night. "A few skeptics huddled in corners shaking their heads. George Armstrong, in full Scottish regalia, piped us in. An Old Town School tradition was started. Bill Bronzy gave us a demo of his powerful guitar playing. Big Bill, black and handsome,

could stir a roomful of uptight humans into a bowl of instant throbbing rhythmic jelly.

"The audience sang and melted the cracked plaster away. The cobwebs vanished and the roaches scrambled. The folk genie popped the cork on the bottle, and great music ran over the room," Hamilton recalled.

# Cops Still Haven't Been Able to Disarm Chicago Aldermen Despite All the Talk about Gun Control

While part of a cop's job is to disarm criminals, people have also been trying to disarm off-duty cops. And not all of them have been "lakefront liberal" reformers.

Back in 1933, 43rd Ward alderman Matthias (Paddy) Bauler tried to pass an ordinance requiring policemen to leave their weapons at work. The city council's unofficial "Clown Prince" began his crusade after being cleared of shooting Officer John Ahearn, a former bodyguard for Mayor Anton Cermak, outside Bauler's saloon at North and Sedgewick.

Bauler said that after he refused to let Ahearn inside his tavern, the officer called him a "big Dutch pig" and then forced his way inside at gunpoint. Bauler, who as an alderman was allowed to pack heat, reportedly said he fired into the ground as a warning, accidentally hitting Ahearn twice. He called it self-defense, and the court agreed.

"It's an outrage to let policemen flourish guns every time they get a few drinks. I'm going to see it stopped," Bauler said after the trial.

But there were apparently some things even Paddy ("Chicago ain't ready for reform") Bauler couldn't do. Chicago cops today still carry guns when they're off-duty, in keeping with the department's thinking that a policeman is on duty 24/7. But in recent years, policemen have been strongly advised

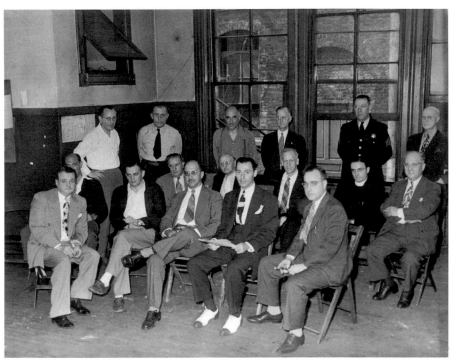

by their superiors to leave their weapons at home if they're planning on doing any drinking.

Aldermen are on their own.

*Opposite, top*: Citizen involvement and the local police go back a long way, as shown here in this early photo of the Safety Club at the old Sheffield Police Station. *Courtesy of the Chicago Public Library.*

*Opposite, bottom*: A policeman keeps the peace in Lincoln Park in the early 1900s. *Ravenswood/ Lake View Historical Association Collection.*

# At Least Two Near North Political Careers Began with a Bang, Ended Because of "Woman Factor"

Politicians like Bauler just wrote their own rules as they went along. Born to saloonkeeping parents in Lincoln Park in 1890, the future epitome of the old-time "machine" politicos began his career with a part-time job in the county treasurer's office, made an unsuccessful run for alderman in 1925 and opened a speakeasy at Willow and Howe Streets where the clientele included singer Rudy Vallee, future mayor Anton Cermak and socialite Edith Rockefeller McCormick. He finally got elected alderman in 1933, when he also opened the DeLuxe Gardens saloon at North Avenue and Sedgewick when Prohibition ended. There, Bauler held court, staged wrestling matches and organized late-night poker games where legend has it the players sometimes included George Cardinal Mundelein himself.

In 1939, when Joseph Waller tried to unseat Bauler, he lost by 243 votes and charged fraud and intimidation of voters. Bauler called the city council's refusal to order a recount "a victory for the people."

Believing one favor deserved another, Bauler and longtime sidekick Charlie Weber, who represented Lake View in the city council, often took off on a whim for Hong Kong or Europe and returned laden with gifts for the party faithful.

Although it's doubtful he ever really said "Chicago ain't ready for reform," Bauler and Weber made little attempt to hide their contempt for the lakefront "Goo-Goos," which is what they called the Good Government crowd. People, Bauler explained, want good service, not necessarily good government.

But even Bauler couldn't forestall change forever. His 1967 retirement paved the way for the election of lakefront uber-liberal reformer George Barr McCutcheon, who had previously been a teacher at the very posh and private Francis Parker School. But the erstwhile darling of the wine-and-cheese set decided not to seek reelection after being caught with a black hooker from Cabrini-Green under the elevated tracks around North and Clybourn Avenues. McCutcheon said he was researching prostitution in his ward. The way things worked in Chicago back then, he would have avoided the whole mess just by showing the arresting officers his aldermanic badge.

Another typical politician of that era got his start in politics with a bang in 1918 when his army plane crashed in Grant Park. The twenty-seven-year-old DePaul University graduate, Dorsey Crowe, was "bombing" the lakefront with Liberty Bond leaflets when he suddenly went into a dive and pancaked on the lawn in front of thousands of horrified spectators. Although the plane was totaled, the fledgling aviator got off with a pair of broken feet.

The next year, still in uniform and hobbling on crutches, the World War I hero who never really left home was elected to the first of ten terms as 42nd Ward alderman. Although he graduated from Kent College of Law in the mid-1920s, the Omaha-born son of a North Dearborn Street hotel keeper divided his time between his real estate office at 25 West Chicago and running his political fiefdom.

Best remembered today as the visionary father of Midway Airport for getting the city council to appropriate the first $25,000, Crowe also fought his share of sometimes-bizarre vendettas. But defeats were rare for the city council dean who had served forty-three years as alderman by the time he died in Lakeside Veterans Administration Hospital in July 1962. He lost one race for municipal court clerk in the early 1920s and was trounced during his first try for the city council two years before dropping into Grant Park.

He was probably the first Chicago politician to blame that early defeat on the "woman factor." "Women just got the right to vote for alderman and they got their first crack at me," Crowe recalled years later. "I got a majority of the men's vote, but the women beat me."

But Crowe, whose wife, Mary, wasn't only a lawyer herself but also a former president of the Chicago Women's Bar Association, wasn't about to be intimidated by the early feminist reformers who kept trying to oust him

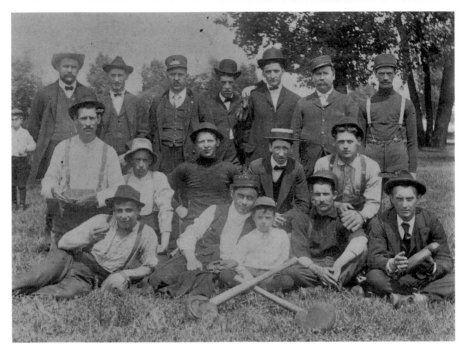

Members of the Limits Car Barn (at Wrightwood and Lincoln) baseball team take a breather sometime around 1902. Ravenswood/Lake View Historical Society collection.

because of his supposed tolerance for corruption and vice. One of Crowe's most memorable moments was when he set straight an early lakefront independent who accused him of buying votes from winos for fifty cents.

"Madame," he coolly replied, "you can't get that done for fifty cents. It costs five dollars."

# IWW Had Scant Success Promoting "One Big Union" but Claims Several Lasting Victories

For the better part of a century, what was once considered by FBI director J. Edgar Hoover and others to be the most dangerous subversive organization in the country operated rather quietly in Lincoln Park—for thirty years above an Assyrian restaurant at 2422 North Halsted and later at 752 West Webster Avenue and in shared space with other groups at Liberty Hall, 2440 North Lincoln. In 2000, after a ten-year hiatus in San Francisco, the international headquarters of the Industrial Workers of the World (IWW) returned home to Chicago, first to 2010–12 West Irving Park Road and later to 2036 West Montrose Avenue—all this despite going from an all-time high of 150,000 members in the early 1920s to near-extinction in the late 1950s, partly because of competition from rival labor movements that later evolved into the AFL-CIO and partly because of the post–World War I "red scare" and the Cold War that followed World War II.

Founded in 1905 by a group of socialists, anarchists and assorted radical trade unionists in Brandt's Hall at Chestnut and Clark, the frankly anti-capitalist IWW is based on the ideal of people owning the industries where they work and electing their managers. Among them were future five-time Socialist Party presidential candidate and railroad union organizer Eugene Debs, Mother Jones and Lucy Parsons, widow of one of the Haymarket

martyrs (or bombers, depending on your point of view). Former Colorado lieutenant governor David Coates also attended that founding convention, but it's never been clear whether he became a member.

Only by grouping all crafts and trades together into "One Big Union," the Wobblies believed, could employees hope to be strong enough to extract a semblance of fair treatment from management.

Not surprisingly, the Wobblies soon became a favorite target of red baiters. Because some factions of the IWW once advocated sabotage where negotiations failed and as the only union to strenuously oppose America's entry into World War I, it was one of the primary targets of the wartime Anti-Espionage Act. Unlike other antiwar groups at the time, the IWW advised its members to register for the draft as required and then identify themselves as members of an organization opposed to war.

In August 1918, 101 Wobblies were tried en masse in Chicago's federal courthouse and given exceptionally heavy sentences, presumably as a deterrent to others, by Judge Kenesaw Mountain Landis, who later became the first baseball commissioner. Throughout the country, hundreds of Wobblies were hanged, shot or jailed. Their most famous martyr, Joe Hill, author of numerous protest songs still sung today, was executed in 1915 by a Utah firing squad on a trumped-up murder charge. His funeral in Chicago attracted hundreds of sympathizers.

During Senator Joseph McCarthy's trials by television in the early 1950s, the IWW was put on the U.S. attorney general's list of subversive organizations, supposedly because of Communist leanings. While the IWW originally backed the Bolshevik revolution in Russia as a blow for the betterment of the working class, the Wobblies became disenchanted with Soviet policies as early as the 1920s. In 1950, an IWW convention formally denounced the Communist Party as a menace to the international labor movement.

But that didn't get the IWW removed from the government's black list, which also included the Ku Klux Klan and the American Nazi Party. Despite years of repeated petitioning to be removed from the attorney general's List of Subversive Organizations, nothing happened until the entire list was finally abolished in 1978 by President Richard Nixon.

Decades before officials began compiling "the List" in the 1940s, Wobblies were singled out for special attention. During World War I, federal agents seized five tons of "red propaganda" in the IWW's Chicago office. Crackdowns on radicals from the "Palmer Raids" of the 1920s to the anti-Communist witch hunts of the 1950s have taken a heavy toll, IWW officials concede.

Despite repeated attempts, the Wobblies haven't even been able to get a posthumous pardon for one of their greatest heroes, Joe Hill. Born Joel Hillstrom in Sweden in 1879, Hill came to the United States in 1903 and was working as a miner near Salt Lake City when a grocer and his son were murdered by two men wearing red bandanna masks. That same evening, Hill turned up in a doctor's office claiming to have been shot in an argument over a woman he refused to name. At least twelve suspects had been arrested before Hill was charged after the same kind of red bandanna often used by IWW members was found in Hill's room. The victim's brother initially told police Hill wasn't the killer but later changed his mind and identified Hill as the shooter. Hill repeatedly refused to name the woman he said he was with that night, who might have served as an alibi.

Before long, the already unpopular IWW was on trial along with Hill himself. On the other hand, pleas for clemency were pouring in from notables including President Woodrow Wilson and Helen Keller, the blind and deaf author who later joined the IWW herself in a show of solidarity.

Immediately before his execution, Hill wrote to fellow IWW leader "Big Bill" Haywood, who would become one of the labor activists tried before Judge Landis. Hill's last word of advice to Haywood was, "Don't waste any time in mourning. Organize. Could you arrange to have my body hauled to the state line to be buried? I don't want to be found dead in Utah."

After his execution, Hill's admirers all wanted a piece of him. Literally. His ashes were taken to IWW headquarters and put in six hundred envelopes. According to legend at least, the cremains were supposed to be sent to IWW chapters around the world to be scattered on May Day 1916. Actually, it wasn't until the first anniversary of Hill's death that most of the packets were distributed. The remainder was finally distributed to the union's locals and Wobbly sympathizers around the world in early 1917.

Or so they thought.

In 1988, one of the envelopes containing some of those ashes was seized by the U.S. Post Office because of its "subversive potential." The envelope, also containing a photo of Hill, had been marked "Joe Hill. Murdered by the capitalist class, Nov. 19, 1915." For more than seventy years it lay forgotten in a drawer in the National Archives until a story ran in *Solidarity*, the United Auto Workers' magazine.

Then things really started getting weird.

*In These Times*, a Chicago-based politically progressive/democratic socialist monthly, called on its readers for suggestions on what should be done with the ashes. The replies ranged from great to grotesque. One reader

wanted them enshrined at AFL-CIO headquarters in Washington, D.C., while 1960s gadfly Abbie Hoffman wanted the ashes eaten by latter-day "Joe Hills" like Billy Bragg. The British singer/songwriter and left wing activist reportedly washed down some of the cremains with a bottle of Union Beer and gave some of the ashes to Otis Gibbs, a folk/country singer who estimates he planted seven thousand trees during his younger days in Indiana. A few of the ashes were sent to Sweden and buried in the wall of a union office behind a plaque honoring Joe Hill. Still others were scattered during a 1989 ceremony remembering six Colorado coal miners who had been machine-gunned by state police in 1927. And in November 1990, Wobblies in Michigan consumed some of the ashes after a dinner and a reading of Hill's last will and testament:

> *My Will is easy to decide.*
> *For there is nothing to divide.*
> *My kin don't need to fuss and moan—*
> *Moss does not cling to a rolling stone.*

Despite very lean times, the IWW continued organizing everyone, everywhere. Even students were invited to join the Wobblies' education workers branch. In the 1970s, they began a drive to organize a sex workers' local in San Francisco, and in 1987, they passed a resolution at a national convention allowing prisoners to form IWW locals.

Not surprisingly, the Wobblies had their share of victories in hometown Chicago. In 1971, the staff at the Lincoln Park–based *Seed* underground newspaper all became members. And the New York–based *Liberated Guardian* became an IWW union shop, as did the wait staff at Alice's Revisited, a then-popular Lincoln Park hippie hangout.

That same fall, the Three Penny Cinema at 2424 North Lincoln Avenue came under fire from the IWW and an assortment of activists for failing to honor its contract with the IWW, as well as the management's "ripoff, sexist pig" policies. To show they meant business, some of the demonstrators donned American Indian war paint and played volleyball with balloons while a troupe of three tumblers in pajamas and long underwear performed in the street.

But there was serious question over who they were supposed to be picketing. The IWW claimed the theater was owned by John Rossen, whose impeccable "Old Left" credentials included serving in the Spanish Civil War's Abraham Lincoln Brigade; running on the Communist Party ticket

for mayor of East St. Louis, Missouri; and owning the building where the IWW has its offices. But Rossen, who was milling among the demonstrators and spectators, passing out handbills telling his own side of the story, said he had recently sold the theater and had no control over its new policies.

The demonstration had been called to protest the Three Penny's failure to honor its union contract and the management's policy of showing an occasional X-rated film. A handout passed out by the dissidents noted the Three Penny once specialized in "social comment" films like *Battle of Algiers* at $3 a head and was Chicago's only fully unionized theater. "Now the management is charging $3 for first run porn and $2,50 for old movies with cheap rental fees," the handbill complained. "All the union employees have been fired in violation of their contract.

But probably the only X-rated film shown there around that time was *History of the Blue Movie*, hailed by at least some reviewers as a ribald classic rather than a dirty film. The theater was showing Charlie Chaplin's *The Dictator* as the pickets milled around.

Although Rossen himself was a tireless labor organizer in his younger days, labor disputes had become nothing new to the Three Penny. The theater had been unionized by the IWW just a little over a year earlier and had its first strike over the firing of its manager, Mimi Harris. In his own handout, Rossen clamed that under Harris's management, about $1,800 in theater receipts had been "liberated," reportedly to feed the neighborhood's hungry children.

Harris was rehired, but picketing resumed in June when Rossen leased the theater to three New York entrepreneurs who refused to recognize the IWW contract, raised the prices, changed the booking policies and fired the staff. The out-of-town operators soon left, and Rossen reportedly sold the theater to someone else.

The dissidents said Rossen offered to show his former employees proof of sale and to give them each $5,000 in severance pay if they would refrain from picketing the new owners. But the protesters claimed he reneged on those promises and that the theater lease was still in Rossen's name.

"From a legal standpoint what this all boils down to is that employees should either have their contract honored or get their severance pay," the handbill said. "Right now, they have neither, but all of us are determined that the theater's management will never feel welcome in the community until they change their current policies of sexism and rip-off," the protesters said.

Negotiations between IWW and the Three Penny petered out, and the theater—long favored by DePaul University students and thrifty movie

buffs—closed during the summer of 2007, owing the city over $100,000 in amusement taxes dating back five years.

Times had been tough, theater owner Jim Burrows told a *Chicago Tribune* reporter. "We are done. Unless I get a call from the city eliminating the taxes agreeing to some payment plan, then that's it. I need to find another job."

In 1964, however, the IWW suffered an even more embarrassing setback when it tried to organize the unemployed in Chicago's Uptown neighborhood, only to be forced to retreat by the Students for a Democratic Society's JOIN (Jobs Or Income Now) project, whose leaders included "Chicago Seven" defendant Rennie Davis.

Four years later, the Wobblies helped organize creation of the Chicago People's Park at Armitage and Halsted in opposition to urban renewal plans that included putting a private tennis club on the site rather than the affordable housing many activists were demanding at the time.

Over the years, the IWW tried with mixed success to organize some McDonald's restaurants in 1973, and in 1976, it led a strike to back childcare workers at the now-defunct Augustana Hospital at 2035 North Lincoln Avenue. That same year, the union organized a boycott of the Kingston Mines nightclub, then at Lincoln near Fullerton, to get the owner to pay back wages owed to a band that included two IWW members.

Still, some longtime Wobblies like the late IWW general secretary-treasurer Carl Keller have argued that their union's biggest contributions have been ideas like Social Security that were picked up by bigger, more powerful labor groups like the AFL-CIO. The fact that many IWW members were also involved in other unions at the same time promoted a kind of cross-pollination of ideas, Keller told *Old Town Voice* in 1965.

Over the years, members have included academic gadfly and self-described "libertarian socialist" Noam Chomsky, American Civil Liberties Union founder Roger Baldwin, playwright Eugene O'Neill and former Minnesota governor Floyd Olson, along with Catholic Worker founder Dorothy Day. And although not a member, Emma Goldman, once dubbed the "High Priestess of Anarchy," reportedly had close ties to the IWW.

# How an "Old Red" Found New Sense of Purpose Promoting "New Patriotism" at Liberty Hall

Looking back on his past, you wouldn't expect John Rossen to be an American flag waver.

Back in the 1930s, he was a Communist Party organizer and a lieutenant in the Abraham Lincoln Brigade, a group of American leftist volunteers who fought against Franco in the Spanish Civil War.

During his World War II service in the U.S. Army, Rossen recalled spending much of his time being shifted from one "Mickey Mouse" job to another because the powers that be didn't trust "premature anti-fascists" like him. When he finally got sent to India as an aircraft mechanic, he became one of the few American servicemen declared persona non grata for having too active an interest in Mahatma Gandhi's Congress Party.

During the McCarthy hysteria a few years later, Rossen got blacklisted from so many jobs because of his past that he finally bought a theater as a last resort and became, of all things, a capitalist. He eventually acquired six movie houses, including the Three Penny; Festival at 3912 North Sheridan Road; and the Palacio, a few blocks north at 4040 North Sheridan Road, specializing in Spanish-language films.

Later, he became better known as the owner of Liberty Hall at 2424 North Lincoln Avenue, the one-time home office of the IWW and several

other New Left groups, including a committee to impeach Nixon and a local chapter of the People's Party that ran "Baby Doctor" Benjamin Spock for president in 1972.

But to Rossen, his most important tenant back in 1976 when the whole country was celebrating the bicentennial of American independence was the Sons and Daughters of Liberty he helped found with environmental and economic equality activist Jeremy Rivkin. The idea was to work with the nationwide People's Bicentennial Commission to keep the 200th anniversary celebrations from being hijacked by the "Tories," as Rossen liked to call the business and political establishment. Both Rossen and Rivkin considered the American Revolution a work in progress. Their response was the People's Bicentennial Commission to help promote what Rossen called the "New Patriotism."

The latter-day Continental soldier insisted that the only way the United States would survive wasn't by parroting Marx or Mao but a recommitment to the principles of our founding fathers as expressed in the U.S. Declaration of Independence and Bill of Rights. "America needs some rather extensive changes, but a debate over the merits of Stalinist versus Trotskyite philosophy isn't relevant to modern America," he said. Americans should instead draw on their own revolutionary traditions rather than Russia's, China's or Cuba's, he added.

And while Rossen and his followers often wore tricorn hats and carried "Don't Tread on Me" flags, they had absolutely nothing in common with the Tea Partiers of more recent vintage. "Even in the 1930s, I was critical of radicals who forgot our own revolutionary heritage and became obsessed with foreign heroes and ideologies," Rossen said.

"A few people on the Old Left thought I had something, others agreed, but didn't want to go as far with it as I did. Most just thought I was nuts."

He added that his only reason for becoming involved with the Communist-led movements in the first place was that during the Depression years at least, they were about the only progressive organizations with any kind of programs for social change. "Since then, we've seen a lot of programs first proposed by radicals become part and parcel of government policy. Social Security is just one example," Rossen added.

But today, both the old and new left have probably outlived whatever usefulness they might have once had, he said. "Labels like right wing or left wing are irrelevant today. The question now is whether you believe in a government that serves the people's interests or whether you are a Tory who supports King Richard Nixon and his favored few," Rossen said.

It was not surprising, Rossen added, that these new battle lines had already made allies of people who protested the Vietnam War and social and economic inequality at the 1968 Democratic convention and states' rights supporters who voted for American Independent candidate George Wallace, the third-party contender in that election. Both factions, seemingly poles apart, shared a basic concern for individual rights under the Constitution but, at that time at least, felt compelled to express those concerns differently, Rossen argued.

"Actually, both the right and left wings had a lot in common with one another," he went on. "They might have even joined together if it weren't for the fact that the right-wingers had a tendency toward racism at that time and the left-wingers often got themselves involved in some pretty stupid antics."

If it seems odd for radicals to be rallying around the American flag, Rossen said, "that's largely because the symbols of the American Revolution have too often been preempted by people who would have been Tories 200 years ago."

# REMEMBER THE WEBSTER, WRIGHTWOOD, BUENA EL STOPS? THERE WAS A LOT MORE SERVICE THEN

For mass transit riders, July 31, 1949, will live as a day of infamy. That morning, twenty-three elevated stations were shut down forever as part of a cost-cutting drive by the newly created Chicago Transit Authority (CTA).

For whatever reason, the area around the Lincoln Park neighborhood was among the hardest hit. The casualties in Chicago's largest station shutdown before or since included stops at Oak, Webster, Wrightwood, Clark and Roscoe, Grace, Buena and the Ravenswood Avenue station near Montrose. The old Willow Street stop had already been closed since 1939 to make way for the subway completed three years later. And the Grand Avenue and Paulina stations were shuttered in the early 1970s. The Paulina stop reopened on a limited basis a month later and returned to full service in November 1987. The Sedgwick stop closed and reopened several times over the years.

But these and other service changes have never been a surprise to transit buffs like amateur historian Roy Kohl, who back in the early 1980s said its inevitable stops will come and go with the ebb and flow of the city's growth. "But all these stations were in strategic locations. When they stopped being important for whatever reason, they were usually closed," Kohl explained.

Public transportation has always been an important part of Chicago life since at least the 1870s, when a small steam engine with three cars ran three times a day along Evanston Avenue (today's Broadway) from Fullerton to Graceland Cemetery and west to Green Bay Road (now Clark Street). The three-mile trip took about fifty minutes. By 1883, a streetcar that ran up Lincoln to Diversey prompted development of new subdivisions at Lincoln/Wellington/Lakewood where lots sold for between $400 and $1,100.

But until the elevated trains made their debut around the turn of the century, communities like Lake View, Ravenswood and even parts of Lincoln Park were psychologically, at least, cut off from downtown by the Chicago River and unable to compete with the then faster-growing South Side.

Work on the Northwestern Elevated Railroad began in 1897, just four years after Chicago's first elevated trains started running from Congress Street to Jackson Park to bring visitors to the Columbian Exposition.

In 1900, trains ran from downtown to Wilson Avenue, although the line almost died before it was even born when it was shut down by police during a legal wrangle over some questionable Lake Street Elevated Line stocks in an era when Chicago was served by five different public transit companies. The line not only survived but even added the Ravenswood route in 1907. By 1921, work had started on an elevated extension through Evanston.

Kohl predicted routes will continue changing as needed. "It's almost a living thing," he said of the CTA system. "And successful living things learn to adapt."

# 1934 Deering Plant Blaze
## Almost Picked Up Where the
## Great Chicago Fire Left Off

Incidentally, the 1871 fire wasn't the only conflagration that almost destroyed Chicago. If you don't remember what happened on June 20, 1934, you can probably thank the quick-thinking firemen who kept an extra-alarm blaze at the vacant Deering Plant near Diversey and the river from reaching the Murphy-Miles Oil Company at 1801 West Fullerton Avenue, where more than one thousand gallons of gasoline were being stored.

It may have been Chicago's first brush with obliteration since the Great Fire, agreed many of the more than fifty thousand people—undoubtedly including a few who had been there for the "big one" sixty-three years earlier—who watched as firemen manned fifty pieces of equipment, battling a blaze that threatened homes as far north as Wrightwood Avenue, as well as two nearby lumberyards and dozens of factories like the Quality Bottle Company at 2316 North Elston, where an employee was slightly injured helping to put out the fire in the Deering.

He was one of only two people injured by the Deering fire, which only did between $10,000 and $50,000 worth of damage. The loss was so small because the plant had already been shut down by the Depression and was about to be razed when one of the buildings accidentally caught fire from a wrecker's acetylene torch.

At its height, the Deering Works had seven thousand employees annually turning out more than forty-five thousand tons of twine and

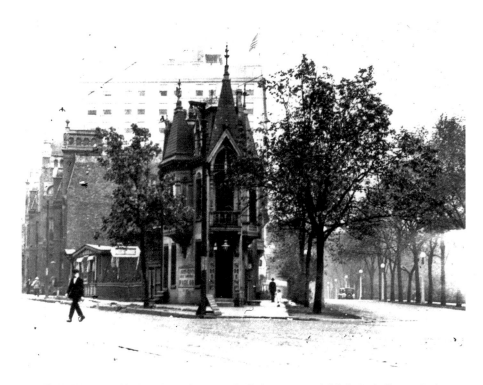

The Relic House at Clark and Armitage was built from assorted debris, including melted sewing machines retrieved from the ashes of the Chicago fire. It moved to three locations before ending up as a shoeshine parlor. *Ravenswood/Lake View Historical Association Collection.*

300,000 farm and industrial machines, mostly rolling mills. Founded by William Deering in Plano, Illinois, in 1858, the farm machine factory moved in 1880 to an eighty-acre site along the Chicago River between Fullerton, Clybourn and Diversey.

The plant was virtually a self-contained city by 1903 when it merged with the McCormick Reaper Co. and three other companies to form International Harvester (IH, now Navistar). The Deering complex had its own streets, trains, an electric powerhouse, telephone system and America's largest private fire department. But by 1934, IH had already laid plans to sell off the Deering works, part of which would soon become the Lathrop Homes, dedicated by First Lady Eleanor Roosevelt.

# 1901 CAR BARN FIRE LEFT HUNDREDS OUT IN THE COLD

An earlier brush with real disaster came the weekend of December 15, 1901, when streetcars melted and commuters froze. Many North Siders learned for perhaps the first time what truc miscry is all about.

First, it got so cold (eleven degrees below zero) that an underground cable on Clark Street snapped, halting streetcars along the entire route. Then service on Lincoln Avenue to Belmont stopped when fire gutted the Union Traction car barns at Sheffield and Wrightwood early on Sunday, December 15. The blaze reportedly started in an overheated stove and devoured two hundred streetcars (including one hundred summer coaches) stored on the second floor and then jumped across Sheffield Avenue and did $1,500 worth of damage to James Lomax's house.

At one point, the heat was so intense that it broke windows in every building facing the car barns. It took at least four hours before firemen finished hacking their way through the thin ice to get at nearby hydrants. By noon, little was left of the 260- by 190-foot building, which had replaced an earlier car barn that had been destroyed in an 1895 fire. Despite $150,000 worth of damage, including most of the North Side's cable cars, shuttle service ran every four minutes to Clark and Armitage Avenues using rolling stock brought in from the West Side barns.

But by then, there were few riders. The streets were deserted except for a handful of hardy souls like Antonio Buchschuler of West Fullerton Avenue, who started walking after being told there were no streetcars running south on Clark Street. Somewhere along the way, he met thirty-two-year-old Rose

Lee. The two walked and talked until he slipped on the icy pavement and Rose made off with his pocket watch.

Even then, there were days when it just didn't pay to get out of bed in the morning.

# Bibliography

Andreas, Alfred T. *History of Chicago.* Chicago: A.T. Andreas, 1885.

Bielski, Ursula. *Chicago Haunts.* Chicago: Lake Claremont Press, 1998.

Brugher, Shirley. *Hidden History of Old Town.* Charleston, SC: The History Press, 2011.

———. *Living in Interesting Times.* Chicago, 2010.

*Chicago Sun-Times.*

*Chicago Tribune.*

*Crains Chicago Business.* Chicago, n.d.

Eldedge, Jim. *The Tragic Life of an Outsider Artist.* Chicago: Overlook Books, 2013.

*Encyclopedia of Chicago.* Developed by the Newbery Library with the cooperation of the Chicago Historical Society. Chicago: Newberry Library, 2004.

Fewkes, Tom. *DePaulia.* Chicago, 2013.

# BIBLIOGRAPHY

Grossman, Ron. *Guide to Chicago Neighborhoods.* Chicago: New Century Publishers, 1981.

Haynes, Don, and Tom McNamee. *Streetwise Chicago.* Chicago: Loyola University Press, 1988.

Heise, Kenan, and Mark Frazel. *Hands on Chicago.* Chicago: Bonus Books, 1987.

*Inside Publications.* Chicago, 2008–14.

*In These Times.* Chicago, n.d.

Johnson, Raymond. *Chicago History: The Stranger Side.* Lancaster, PA: Schiffer Publishing, Ltd., 2014.

Keating, Ann Durkin. *Chicago Neighborhoods and Suburbs.* Chicago: Bonus Books, 2008.

Lerner Newspapers. Chicago, 1965–93.

Lindberg, Richard. *Return Again to the Scene of the Crime.* Nashville, TN: Cumberland House, 2001.

———. *Return to the Scene of the Crime.* Nashville, TN: Cumberland House, 1999.

Meyer, Ray, with Ray Sons. *Coach.* Raleigh, NC: Contemporary Books, 1988.

Miller, Donald L. *City of the Century.* Chicago: Simon & Schuster, 2003.

Pacyga, Dominic A. *Chicago.* Chicago: University of Chicago Press, 2003.

Sawyer, June Skinner. *Chicago.* Chicago: Loyola University Press, 1991.

Shulman, Dr. Stanford. *Children's Memorial Hospital.* Charleston, SC: Arcadia Publishing, 2014.

# ABOUT THE AUTHOR

Patrick Butler is a lifelong Chicagoan who has covered the North Side for over four decades, most of them as a reporter for the Lerner Newspapers. He currently writes for Inside Publications *Booster*, *News-Star* and *Skyline*, which covers Lincoln Park and the Near North Side. Earlier he was editor of the *Old Town Voice*. Butler has served more than a dozen years as president of the Ravenswood/Lake View Historical Association and for several years was an on-camera reporter and anchor for a cable TV/news magazine, *North Side Neighbors*. Mr. Butler has interviewed presidents, prime ministers, death row inmates, pimps, ladies of the evening, pagan priests, B&D doms and queens, drag and otherwise. He holds two Peter Lisagor Awards and numerous other local, state and national honors.